"Maria holds your hand and builds your color confidence, page by page with her smart tips, clear explanations and easy exercises. Her teaching experience and style are obvious as I felt like I was taking an at-home class just with her. I appreciate having her book on hand as a resource when I need a reference for pulling fabrics together and want to expand my color horizons."

—Joan Hawley, Lazy Girl Designs, www.LazyGirlDesigns.com

"I've attended several lectures on the color wheel, but none of them made me start thinking about color the way that Maria Peagler's Color Mastery did. All of a sudden I had fresh eyes, and looked at everything around me with greater understanding. This book is an instant classic."

—Kay Mackenzie, appliqué designer, www.quiltpuppy.com, *Easy Appliqué Blocks: 50 Designs in 5 Sizes*

"Maria is a gifted teacher who understands your fears and frustrations with quilt color combinations. She does a beautiful job of merging the normally dry process of learning color principles with intuitive exercises that let you relax and play. While Color Mastery doesn't cover color mixing for painters, it's really perfect for quilters who use fabrics to create their color imagery. It's packed full of useful charts, illustrations, tips, things to think about, color wheels and harmony patterns."

—Susan Shie, www.turtlemoon.com

"Wonderful, thoroughly researched book that unravels the mystery of color with both exercises and projects. Maria's playful attitude shines through - she's made the projects and exercises so much fun! This book is a great resource for anyone trying to learn more about color."

—Carol Taylor, quilt artist and teacher, www.caroltaylorquilts.com

"Come along as Maria Peagler guides you through journaling techniques to find and develop your own color skills. You will fondle fabrics and bond with the color wheel in more ways than you thought possible as the elements of color jump off the pages of this book and into your creative life!"

—Marti Michell, quilter, author, teacher, Silver Star Honoree 2004

"A helpful addition to any quilter's library. Color Mastery provides a wealth of advice on making your fabrics' colors work for you. Maria's best advice: keep a color journal to record appealing color combinations, then use color theory to analyze why you like them. Her recommendation to audition potential fabric swatches is a lifesaver - better to sacrifice a few small pieces of fabric than to discover colors aren't working together after you've cut out all the pieces. I especially liked the explanations of which parts of standard color theory only work for paints where the colors are mixed together and which parts are important for designing with fabric."

—Martha Sielman, Executive Director, Studio Art Quilt Associates, Inc., www.SAQA.com
Masters: Art Quilts (Lark Books)

"Are you no good at color?" Spend time with your stash and Color Mastery and become a master! By training your eyes, Maria's ten principles make working with color intuitive—and fun. Change your attitude about color from fear to play!"

—Jodie Davis, President, QNNtv, www.QNNtv.com

"As a workshop instructor, I realize that making the right color choices is both a difficult task and a crucial one. Maria voices the struggles and decisions that plague all quiltmakers (whether traditional or contemporary) and shows how to develop color schemes that are not only pleasing, but also rich and satisfying. Maria takes the guesswork out of color choices."

—Elizabeth Barton, art quilter, www.elizabethbarton.com

COLOR MASTERY:
10 Principles for Creating Stunning Quilts

MARIA PEAGLER

Willow Ridge Press

Printed in China by Everbest through Four Colour Imports, Ltd., Louisville, Kentucky

Published by Willow Ridge Press, LLC, 10690 Big Canoe, Jasper, GA 30143.

Editor: Nancy Rosenbaum
Technical Editor: Lila Scott
Cover and Book Designer: Tressa Foster (www.fresh-concepts.com)
Illustrator: Luciana Conceicao
Photographer: gregory case photography

Attention Copy Shops: Please note the following exception—Publisher and Author give permission to photocopy pages 23, 35, 91, and 92 for personal use only.

Attention Teachers: Willow Ridge Press encourages the use of this book as an instructional text. If you are teaching the Color Mastery class, each student must purchase a copy of this book. Please contact Publisher for group discounts.

Library of Congress Catalog Card Number
2008931647

Library of Congress Cataloging-in-Publication Data
Peagler, Maria
Color mastery: 10 principles for creating stunning quilts / Maria Peagler
p. cm.
Includes bibliographical references and index
ISBN 978-0-9816277-0-0
I. Patchwork quilts—Design. 2. Color in textile crafts. I. Title.
TT835 .P44114 2009
746.46—dc21 99-06063
CIP
First printing: February 2009
Second printing: May 2009

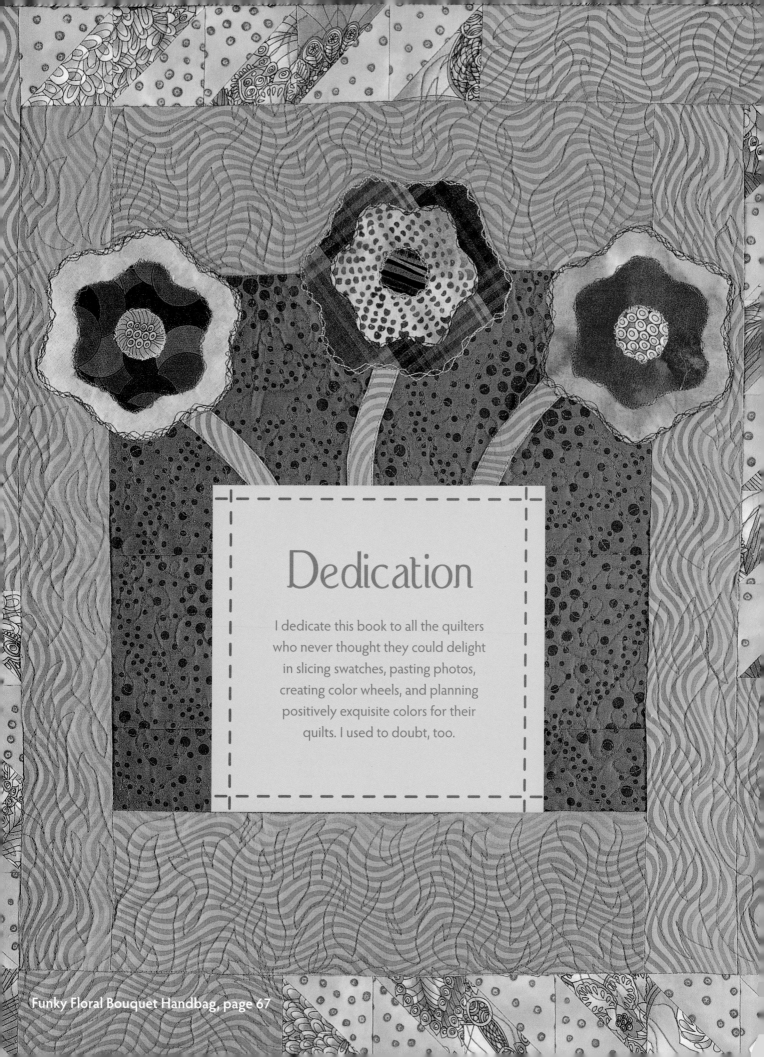

Dedication

I dedicate this book to all the quilters who never thought they could delight in slicing swatches, pasting photos, creating color wheels, and planning positively exquisite colors for their quilts. I used to doubt, too.

Funky Floral Bouquet Handbag, page 67

Acknowledgements

A book is an undertaking of enormous magnitude. It cannot be accomplished alone. I am blessed to have the assistance of a creative team of professionals, supportive friends, and loving family who made the completion of this book possible.

Nancy Rosenbaum made me sound so much better—she knew exactly what I meant to say. Lila Scott is a wizard with numbers, and she took my instructions and actually made them work. Luciana Conceicao's wonderful illustrations added impact where words alone would have been inadequate. Tressa Foster's cover and book design gave this book the visual artistry so essential to the majesty of quilting; she made this quilting book an art book. Gregory Case, photographer extraordinaire, captured aesthetic images that accurately depicted the colors in each of the quilts, and his artistry enhanced the quilts themselves.

Jeanne Rish, of Sew Memorable in Dawsonville, GA, was the first quilt shop owner to offer the Color Mastery class; her tremendous support and encouragement continue to allow me and all quilters to dream ever more beautiful designs. Pat Froelich pieced and quilted more than one project in this book, and rescued me from the dark abyss of stitching. Kathy Brigman courageously pieced her first quilt for this book. Kay Stanley came up with the brilliant title. Gwen Marston and Beth Ferrier gave me invaluable professional advice.

And lastly, my endless thanks to my devoted family: Zach, my smiling angel, gave me honest color advice when I asked for it; Sam, my cheerleader, readily shared his opinion on the quilts; and David, my fellow traveler through eight books, has endured all the adventures with unmatched support.

All of this was made possible through God's grace and blessings, for few ever imagined an indie-published quilting book could be so outstanding. "I can do all things through Christ who strengthens me." Philippians 4:13.

CONTENTS

PART ONE: Color Mastery Workbook

PART ONE

Color
Mastery
Workbook

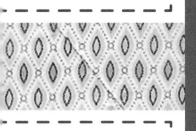

Orientation to Color Mastery

You are holding in your hands a quilting book of a different kind. Most books on color for quilters show photographs of masterpiece quilts, present you with a color wheel, and say, "Off you go! You, too, can do this!"

Maybe they could, but I couldn't. I know, because I tried. It's an enormous leap to look at a printed color wheel and then make a real fabric quilt with it. Using a color wheel is not a natural, intuitive process for most quilters, including me, and colors printed on paper don't accurately represent colors ingrained in fabric. The answer? A map. This book contains a road map to the process for using colors and making them work together every time. You won't be limited to just the colors you like, only those you see in nature, or any other such random rule. I will literally show you how make any color work with any other color. I show you how to make colors behave and play well together. Follow the map—the ten principles—and your quilts will be transformed from blah to brilliant!

Ten Principles of Color Mastery

Quilters who use color effectively develop creative habits that continually train their eyes, keeping them sharp and focused. Long-time quilters instinctively "know" these habits, and, until now, everyone else had to wait and hope for that "aha!" moment. Well, fellow quilters, the wait is over. I've uncovered the ten principles, those precious creative habits, you can use to guide your color selection process. Each chapter in this book contains exercises that demonstrate these principles. From creating and keeping a color journal to identifying the three elements of color and orchestrating harmonious and complementary color combinations, these exercises are intended to help you understand how to use the fabrics you already have to create more spectacular quilts. In short order, these principles will become second nature. Until then, think about the ten simple principles listed on the next page and detailed throughout this book. Get ready to put these principles into practice and experience the joy that comes from designing beautiful, colorful quilts.

Ten Principles of Color Mastery

1. Keep a color journal to record your color discoveries.

2. Use the first element of color—hue—to identify the color itself.

3. Harness the second element of color—value, or the lightness or darkness of a color—to incorporate three dimensionality into your quilt.

4. Master the third element of color—intensity, also known as color saturation—to manage the brightness of your quilt colors.

5. Use Analogous, low-contrast color harmony for subtle color blending.

6. Apply Complementary color harmony using opposite colors on the color wheel for high contrast.

7. Opt for Round-Robin color harmony to achieve low contrast and variable color.

8. Use Triadic color harmony for medium contrast and a variety of colors. Triadic color harmony may well be the perfect color harmony.

9. Use Split-Complement color harmony for medium contrast.

10. Apply Double-Complement harmony for higher contrast and lots of colors.

Chapter 2: Keeping a Color Journal, encourages you to cultivate the creative habit and discipline of recording your color vision. The supplies you'll need and the best approach to mastering this process are covered here.

Chapter 3: Uncovering the Secret to Stunning Color Combinations, unveils the secrets of color relationships and fabric. This chapter explains the three elements of color, what they do, and how to use them in your quilts. I offer tips for building a better, more usable stash. It's more than a matter of buying on sale and swapping with friends. Don't skip this!

Chapter 4: Mastering Hue—The Celebrity Element, elaborates on the star of the show—hue. I explain, step by step, how to create a color wheel from your own stash, as well as how to see your fabrics with an artist's eye. This chapter is key to your understanding of how to use color in general. Trust me, you'll never look at bolts of fabric the same way again after completing the exercises in this chapter.

Chapter 5: Mastering Value—The Workhorse Element, explains why value is so important to beautiful quilt design. I show you how to select just the right values for your quilt design, and how to see a greater range of values in your stash than you thought you had. This chapter really opens your eyes to the possibilities lying on your fabric shelves.

Chapter 6: Mastering Intensity—The Best-Kept-Secret Element, addresses the most elusive element of color—intensity. Few quilters, even the most experienced of us, understand the role of intensity in a color palette. The exercises in this chapter are designed to help you recognize your natural preference for intensity, break out of an intensity rut, and shop for a greater variety of fabric intensities.

Chapter 7: What Every Quilt Needs—The Dance of Harmony and Contrast, provides techniques to help you evaluate your color choices by applying the concepts of harmony and contrast to achieve optimal color effectiveness in your quilts. The exercises in this chapter focus on intuitively identifying harmony, understanding how to achieve it, and recognizing how much contrast an individual quilt needs, based on its design. This chapter also includes my top ten color mastery tips. Once you know how to master color, these guidelines and tips keep you on track, so you won't retreat into old habits.

Chapter 8: Basic Color Harmony Projects, contains four quilt projects: two color harmony quilts, a bonus quilt, and a quilt that shows the impact of neutrals on other colors. This chapter is a great place to start, since each of these projects can be made by most quilters in just one day.

Chapter 9: Sophisticated Color Harmony Projects, contains four color harmony projects that range from feminine to masculine and scrappy to funky. Once you've completed the workbook exercises and finished at least one of the basic color harmony quilt projects in Chapter 8, you're ready to move on to one of the four more advanced color concept quilts this chapter offers.

Chapter 10: Creating Your Own Color Harmony, empowers you to create your own color harmony and offers a masterpiece quilt as encouragement. Once you understand the rules of color relationships, you'll be ready to have some fun bending them, all the while using the three color elements to your advantage. This chapter walks you through the process of creating an entirely new color harmony, and uses a gorgeous quilt project as an example.

Chapter 11: Frequently Asked Questions About Color, contains the questions about colors I hear most frequently from quilters in my classes. If you've ever wondered about it, it's probably here, along with some additional questions that will really challenge what you've heard before about colors in your quilts.

The appendices contain helpful charts and details about an at-home Color Mastery retreat. I'd love to meet you in one of my upcoming classes, but

if you can't attend, why not have your own retreat for yourself and with your quilting buddies! The itinerary from my Color Mastery retreat is here to guide you.

Color Mastery for All Fiber Artists

I teach color classes for all stripes of fiber artists, not just quilters. These classes are offered at a local arts center near my home in the beautiful Appalachians in Georgia. This locale has a rich heritage of folk arts and crafts, and my students range from knitters, rug-hookers, weavers, and embroiderers to collage artists who yearn to understand how to improve the color quality of their work. The ten principles outlined in this book work for all fiber artists, not just quilters. Fiber artists of all types will likely find the insights and exercises in chapters 2 through 7, as well as the frequently asked questions (and answers) in Chapter 11 particularly useful.

Top Ten Color Myths for Quilters

I've taught color classes for years. I've had literally hundreds of students in my classes and I've heard every imaginable excuse for why it took some of them so long to finally commit to learning about color. Most of the objections have to do with learning how and why to use the color wheel. After all, choosing colors is the fun part of the process, so why make it such an academic ordeal? Just for fun, see if any of these misconceptions about quilters and the color wheel sound familiar. Then, take a minute to think rationally about how I bust each particular myth and why the wheel is such an important and fun tool:

1. I have to be an artist to understand all the theory and terms behind the color wheel.

Any quilter, from traditional to contemporary, can use the color wheel to improve the visual appeal of her quilts. The only people I would not specifically encourage to use the color wheel are

those just starting out in quilting. Newbies, don't be discouraged. First, master the basics: cutting, piecing, and the quilting process itself. Then you'll be ready to appreciate and apply an understanding of the color wheel.

2. I have to be a designer and create original quilts to use the color wheel.

You can use the color wheel for any quilt, whether it is derived from a new pattern, a classic pattern such as the Bow-Tie, or one you design yourself.

3. The color wheel is for painters. Quilters don't need it.

Painters need the color wheel to mix colors like lavender, chartreuse, or pink from basic colors straight from the tube. Quilters have the luxury of being able to go into a quilt shop and choose from an entire palette of fabrics that someone else has made. But because someone else has done the hard work of designing and making those fabrics for them, quilters understand less than painters about how colors work together, and the number one complaint I hear from quilters is, "I don't understand how pick the right colors for my quilt." Quilters may not need to use the color wheel as much as painters do, but it certainly improves the look of the finished quilts.

4. Using the color wheel is too complicated for me.

If you can piece a consistent ¼" seam, achieve sharp points, and match seams, learning the principles of good color using the color wheel should be a breeze. I find quilters often don't give themselves enough credit for how hard they work at mastering a technique, and once they do, they forget how hard they worked to attain that expertise.

By dedicating some time to learn how to use the color wheel before you get too deeply involved

in designing and assembling a quilt, you'll actually spend less time in selecting colors and fabrics for your quilt. Using color principles will simplify your quilting process!

5. I'll lose my own style if I use color principles. My quilts will look formulaic.

We all have our own color preferences. I've always loved intense colors and lots of contrast in my quilts. That love didn't diminish when I started using the color wheel. Instead, I learned how to make those intense colors work better with other colors and fabrics.

Color principles can also be helpful if you're ready to transcend your tried-and-true routine and dabble in a new color palette. If you've always made quilts using reproduction fabrics, the color wheel can help you make a quilt using Asian, contemporary, or other types of fabrics you're not accustomed to using. The color wheel can take the fear out of the unknown!

6. I have to dye my own fabric to use the color wheel.

The color wheel works with all fabrics: commercial, hand-dyed, antique, you name it. It's all about putting colors together, no matter where they came from. And color wheels work for all kinds of fibers, not just fabric, so they work for knitters, too, even those who don't dye their own fleece.

7. I would require an enormous stash to use the color wheel.

Nothing could be further from the truth. The color wheel can help you to more effectively use the fabric you already have. And if the quilt shop is missing the "perfect" fabric you thought you needed for your background, border, or binding, your knowledge of the color wheel will help you know exactly what to look for in a substitute fabric.

8. Color principles are only for contemporary quilters/quilts.

All quilters and quilts benefit from understanding why some colors are stunning together while others look drab. Color principles can help you to understand how to draw attention to or away from a specific area of your quilt through the judicious use of color. And that applies to all quilts, not just contemporary ones.

9. Using the color wheel will be expensive for me—I'll just want to go out and buy more fabric!

Quilters covet fabric, knitters covet yarn, weavers covet fleece. Having or not having a color wheel won't change those characteristics of our artistic nature. My point is that, by understanding and using the guidelines for creating harmonious color combinations, you can use the fabric you have more effectively. You won't need to go out and buy more fabric—unless it's a day with a "y" in it.

10. Why should I learn better color techniques? I like my quilts just fine as they are.

If you are a quilter who absolutely, positively, and thoroughly loves all the quilts you have ever made and never wanted to change a single thing about any of them, I admire and salute you, and will submit your name to the Quilter's Hall of Fame.

For the rest of us, we have all, at one time or another, been frustrated by the prospect of selecting from among multiple perfect fabrics, working for months on a quilt, and being less than completely thrilled with the results. Who knows what happened, but the finished product didn't look as fabulous as we envisioned in our minds. The color wheel can help you avoid that disappointment by planning and choosing the relationship between your colors and designing the effect the finished quilt will have.

Adopting a Playful Attitude About Color

I greet many intimidated quilters in my classes. They thirst for knowledge after years of frustration, but they're afraid to ask questions. I've even had students who did the exercises before the scheduled class so they wouldn't look foolish.

Here's my philosophy: choosing your colors and selecting your fabrics is the fun part of making any quilt, so why ruin it by getting so serious and knotted up? Have fun! Play at this stuff. It's just fabric, and you'll be using tiny swatches in these exercises. Really—it's just you and your stash. No one is looking over your shoulder. And who cares what anyone else thinks? It's your quilt—make it your way!

Color Wheel, Rotary Cutter, and Sewing Machine: They're All Just Tools

Sewing machines and rotary cutters completely transformed the quiltmaking process, rendering it easier and more productive. Compared to hand-stitching and scissor-cutting, these pieces of equipment allow us to make quilts in record time. But remember, they're just tools. They make my life easier, but they're not the focus of my quilts. And neither is the color wheel.

The color wheel and the harmonies I create by using it make my color decisions easier, less agonizing, and I'm much more confident in my color selections. Did I mention I achieve outstanding results from using the color wheel? I do. The principles I advocate here aren't my focus. They just make my quilts look oh so much better and they can do the same for yours.

The colors I see around me inspire me: a child's outfit, my kids' drawings, a flower, a painting by one of the Great Masters. I see colors and wonder what they'd look like worked into a quilt. When I get past the admiring and reach the point of wondering,

that's when I engage the color principles process.

Design and fabrics are the focal points of a quilt. The color principles process enhances these focal points by empowering you to make better fabric choices, selecting colors whose relationships work well together to create a really powerful design. The color principles process is a road map, a supporting player, and I don't create a quilt without it. It's not all that difficult to follow and practice makes it even easier.

Understanding the vocabulary of color and learning how to apply the ten principles takes some work; there's no getting around that. But I think it's fun work; after all, we're not scrubbing the kitchen floor here. The process is one of discovery: uncovering the relationships colors have to each other, realizing your own color style, and marrying the two so you can make your color preferences work in every quilt you make. This is not the CliffsNotes version of understanding and achieving successful color selections. Completing the exercises in the various chapters will help you to master the concept of color, and it does take time. But what a difference it will make in your quilts. I promise.

Beyond the Color Wheel

There's lots of information available on the color wheel and and how to select colors for your quilt. Color wheels aren't a new invention, but going beyond the color wheel IS news. Understanding the principles of color harmony is not, in itself, enough to make a successful quilt, but that knowledge will get you much closer to your objective and each chapter provides information on the various aspects of color harmony that can help you to design a more visually appealing quilt.

Fabrics aren't paints: we're not mixing two fabrics to get a third one in a brand new color. Also, fabrics have texture, scale, and undergo a different dying and development process than do paints.

Our criteria for selecting fabrics goes beyond just color. There are other ingredients of color that, when combined appropriately, help to achieve a successful palette. I explain about those other secret recipe ingredients in Chapter 3.

An important note: You've made an investment in better color choices for your quilts by purchasing this book. Don't let it languish on a shelf. Make an investment of your time, too. Color mastery is not something you can learn about by reading; you see it for yourself using your own fabrics. The exercises I've designed are essential for refining your color vision skills.

Basic Color Harmonies

When you were a beginning cook, you didn't start out trying to make a cheese souffle appetizer, roasted duck with root vegetables for the main course, and tiramisu for dessert, did you? Or maybe you did and ended up in tears when your mother-in-law politely declined to eat your creation. Instead, you probably began with the basics, like baked chicken and rice, with pudding for dessert. Then you may have moved on to chicken divan, coq au vin, and more complex recipes and flavors. As you progressed, you added more challenging techniques and exotic flavors.

It's the same with creating color harmonies and what worked when you were learning to cook can work with this process, too. We'll start with the basics: simple color relationships. Does that mean you can use only simple quilt patterns? Not at all. You can use as many colors as you like, but the relationship among these colors will be uncomplicated.

The basic harmonies are also great fall-backs when you need a quick quilt for an impromptu occasion like a co-worker's birthday or a utility quilt for the back porch. Life gets busy, and we don't always have time for a gourmet project. Sometimes you need a 30-minute meal: something quick and easy, but delicious nonetheless. Think of basic harmonies as the go-to palettes when you need something quick but with spectacular results. The basic color harmonies tend to involve either similar colors with low contrast or differing colors with high contrast. Using the color principles process, you'll test your fabric swatches first in your color journal, and once you're happy with the results, you'll be ready to make that quilt.

Sophisticated Color Harmonies

Once you've mastered the basic harmonies, you'll be ready to graduate to the advanced harmonies. These have more intricate color relationships, but their results take less tweaking to be successful. While the simple color harmonies use similar colors with low contrast or differing colors with high contrast, the advanced harmonies are a nice middle ground. Again, you launch the process in your color journal, auditioning swatches for their various roles before committing to a big Broadway production—a quilt.

Your Color Journal

The first step in the color mastery process is to create and keep a color journal. I cannot emphasize enough how vital this step is. This isn't a sophomoric "dear diary" adventure; it's important and it'll make a huge difference in whether you fully grasp the concepts or just nod to them in passing. By building the sample swatches in your journal pages, you should see your fabric stash through new eyes and imagine possibilities and quilts you never dreamt possible before. I keep several color journals at once, and they have become essential tools in my own mastery of color. By experimenting here, on a small scale, before you spend your hard-earned money and precious time on a big quilt, you'll realize this step is a worthwhile and effective investment.

Effortless Projects, Sophisticated Colors

When you're learning something new, you want to keep distractions to a minimum. By doing so, you'll have an easier time focusing on the task at hand. In this case, your task is mastering color, so I've made the quilt projects uncomplicated, yet sophisticated in their design. The objective is to enable you to focus on the color without having to wade through complex instructions and intricate piecing at the same time. The principles explained in these pages are timeless; fabric styles and trends change, but this color course and the quilt designs are classics.

Disguising Leftovers

One of the most clever applications of the color principles involves taking scraps from one quilt project and giving them a makeover, creating an entirely new look. Chapter 9 has two transformative projects, taking scraps from one project in this book and disguising them so you'd never know their origins.

KNOW THIS:
Color Mastery is a ten-step process, a road map, outlined in the following chapters, step by well-planned step.

THINK ABOUT THIS:
Do you know where all of your fabric is stashed?

DO THIS:
Start gathering your fabric stashes into one accessible place. Your entire collection will become your palette for your color mastery journey.

Let's say you have an idea for a quilt. This isn't far-fetched; most quilters are three quilting projects ahead of themselves at any given time. You're itching to get started. You know the design, who it's for, and how much they'll love it when it's all done. You know the construction techniques and you're almost ready to start—except for the colors. You probably have a general idea of the colors you'd like to use, but you're not confident about the combination. Will it look just right? You can't put your finger on exactly what's holding you back and why your color choices don't look as good as those in the pattern or in your friend's quilt. You can see it in your mind, but you can't quite see it in the fabric.

Wouldn't it be easier if you knew how to break down a color palette into a set of ingredients and understand how to replicate those in your own project? What if you could just look at a quilt, a photograph, a magazine cover, or any other inspiring object or element and understand how to translate those colors into a successful quilt? That's exactly what I'm talking about. That's what this book is intended to teach you. I'm not standing behind you with a ruler, ready to rap you on the knuckles. Relax. It'll be fun. There's no pressure here. There are no weird rules, only play, experimentation, and a sense of wonderment. After all, it's about color and color is the fun part of quilting!

Understanding Color Relationships

Can it really be that easy? Is it really possible to identify the elements of successful color palettes in a quilt? Absolutely. And here's why: successful color is all about the interaction of the three elements of color. As you read this book and complete the exercises in it, I hope you'll think about what I'm telling you. If you do, my words, photographs, and examples will help you learn how to identify and play with those elements in your stash, how to recognize your color preferences, and finally, how to combine them in a rich-looking, beautiful quilt.

The process is much like putting your own personal touch on a recipe. When you make a batch of your favorite chili, you shop for and assemble the various ingredients, prepare the dish, and enjoy. Once you know how to make the basic recipe, you can then graduate to more complex versions, trying out new ingredients and putting a different spin on things to make an entirely new dish. You may start out making beef chili, then try white chicken chili, a vegetarian chili, southwestern turkey chili You get the idea. The possibilities are endless, even if you aren't a big fan of chili.

The same process works for using the color wheel. The first time you try using it with a quilt, you'll try out a basic palette, just to get a feel for how those color relationships work with your fabric in a quilt. Then you can graduate to the advanced versions of a palette.

Creating a Color Journal

An absolutely essential tool for any quilter wanting to master the art of color is a color journal. Let's face it: fabric is expensive, and a quilt is a huge commitment of your time and energy. There's no bigger disappointment than investing in fabric and your precious time only to have the resulting quilt be well, less than what you envisioned.

There's a better way, and it's called a color journal. It doesn't need to be fancy or expensive. You don't have to invest in a gold-embossed, leather-bound journal. You just need a binder of some sort to serve as your testing ground, a container in which to try out palettes before you actually use them in a quilt. You don't need to create complicated mock-up blocks or intricate sketches. This is the quilter's version of a thumbnail sketch: as an artist, I often do a tiny, quick sketch to see if I'm on target with a drawing that

will become a quilt or a painting. As a quilter, you'll be doing the same thing by cutting out swatches and pasting them down on paper. If you still need additional visual aids, then you can do a simple mock-up block. The point of using the color journal is to avoid complex tasks early in the process—right now, it's all about the color.

My own color journals contain just about every imaginable color combination. I learned to keep a color journal as a painter, doing color-mixing exercises until I actually dreamt about them. Now, I do a quilter's version of the same color workout. I cut out magazine photos that I interpret into a fabric palette. I don't necessarily cut apart every magazine I come across, but if it's an image that resonates with me, I can't wait to see how it will look translated into fabric colors. I create color wheels so I can better see my stash reflected in a progression of color around the wheel. I create color wheels in solids, prints, plaids, batiks, and novelty

prints. I explore the elements of color by searching my stash for lights, mediums, darks, brights, and dulls. It's here, in your color journal, that each color palette is born.

I keep a variety of journals, some for quilt design ideas, some with inspirational photographs of quilts or nature, some with interesting articles, and almost anything visual that makes me happy. But my color journal is separate. It's a volume set apart for my color exploration, and it calls to me regularly, just like opened packages of chocolate in the middle of the night.

Giving Yourself Permission to Make a Mess

A word about your color journal: this is your place to be creative, to try new things, to succeed, to fail, but most importantly, to learn. By all means, get messy with it. Don't try to make your journal a work of art in itself. I've seen journals filled with gorgeous pages that would inhibit me from trying to add anything new in them; I'd be afraid to damage the overall look of the book. I suspect their makers experimented on scrap paper and then returned to the journal when they were finally ready to create their masterpiece. Do not do this; this isn't the purpose of the color journal. Your color journal is a place for experiments, and sometimes they're beautiful, often they're disappointing, but they're

almost always a mess. Trying to be neat, tidy, and perfect will get you nowhere in these exercises. Be bold, be creative, and be sloppy!

EXERCISE

Stocking Up for Your Color Journal Kit

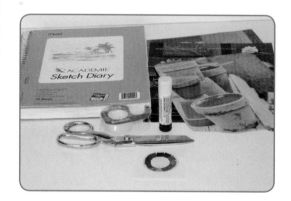

What do you need for a color journal? A simple sketchbook or notebook will do. I suggest getting a sketchbook with heavier paper, as you'll be cutting and pasting fabric swatches on the pages, and regular notebook paper won't stand up to that sort of abuse. The sketchbook doesn't have to be expensive: discount stores sell them in the school supply section. Here are the other supplies you'll need for your color journal kit:

- Sketchbook
- Glue stick or double-sided tape
- Scissors
- Inspirational pictures or photos that you've accumulated over time
- Mini-color wheels (pages 85 and 87)

That's it. Nothing expensive or fancy, just basic supplies that will enable you to play with colors.

KNOW THIS:
Your color journal is a place to discover and refine your color vision.

THINK ABOUT THIS:
Do you avoid trying new things because you're afraid you'll look foolish, or even be disappointed?

DO THIS:
Make a color journal. Now. No excuses.

CHAPTER THREE

Uncovering the Secret to Stunning Color Combinations

Have you ever wondered why some fabrics look fabulous together while other just clash? Why does one fabric absolutely overwhelm the rest and another fabric is practically invisible? It comes down to the characteristics of color. Just like you and I have our own personalities, so does every color. That's why it's so important to understand and identify the three elements necessary for successful color combinations before you select your fabrics. These color characteristics define the relationship colors have to each other and how well they will or won't work as a team in your quilt.

Using the Color Wheel to Understand Color Relationships

The color wheel will be your new best friend, your main tool for mapping color relationships. Frankly, when I first tried to grasp the concept of the color wheel as a newbie quilter, I didn't get it. I finally experienced my "aha!" moment in painting class, where instruction on the relationship among colors was originally taught. Painting teachers realized that, by putting colors in a certain order in a circular shape, the colors formed a predictable pattern of relationships that students could easily understand.

Get ready for your very own "aha!" moment about using the color wheel to understand about color relationships. Here is the key:

Colors close together on the wheel are similar, while those colors farther away from each other are different.

This remarkably simple fact is important, so you may want to read it again, underline it, highlight it, or flag this page. It's the key to understanding the relationship among colors. Those similarities and differences show up in contrast, and contrast is necessary for a quilt's block designs to stand out. Colors close to each other on the wheel have low contrast, while colors opposite from each other on the wheel have high contrast.

Do all quilt designs need contrast? Absolutely. Some quilts need more than others. For example, intricately pieced quilts need contrast to showcase the block design. Art quilters know that contrast is the essential ingredient that turns a piece of fabric into a recognizable shape. Appliquers need contrast to make their appliqués stand out from the backgrounds. Traditional quilt blocks such as Bow-Tie, Bear's Paw, and Broken Dishes need high-contrast colors to define the design. Log Cabin block quilts can use either low-contrast or high-contrast fabrics successfully, depending upon the desired effect in the quilt.

The color wheel has twelve colors, arranged in clockwise order. Notice the absence of names like chartreuse, celadon, amber, crimson, turquoise, or other so-called "marketing" names of colors.

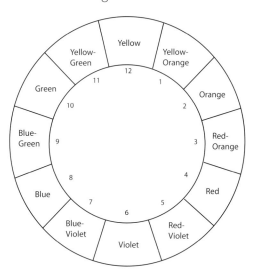

Have you ever tried to pick out a fabric based on a name like lavender or pumpkin, but just couldn't find the exact shade? You could waste an entire day trying to find the right color. Why is it so difficult? Because the names of colors don't identify their color characteristics. Marketing firms earn big bucks to develop names for colors that appeal to your emotions. We may love the idea of a pumpkin palette for our kitchen, but orange? No, orange just doesn't have the same ring to it, does it? What we really need is a way to identify the unique color we need by its characteristics, not by a slick name. Lavender is a light violet, but violet spans a range of pure violet to red- or blue-violet. Which one do you really want and need? Pumpkin is a dull, medium orange. Once you identify those specific color characteristics, selecting the right color is much easier.

Discovering the Three Elements of Color

So what are these all-important color elements?

- **Hue**
- **Value**
- **Intensity**

Understanding the nuances of these elements and how they work together can help you to better identify and pair any color fabric in your stash or favorite quilt shop. Together, these three elements create successful color relationships. Because of the critical role these elements play in your completed quilt, it's important that you not only read the following chapters that cover these elements in detail, but take the time to complete the exercises, ponder the alternatives, and see for yourself how hue, value, and intensity work together using the fabrics from your own stash. Here's a brief explanation of each element to get you started.

Hue

Hue is the name of the color in its most basic form. Red, blue-green, and orange are hues. Pink, navy blue, and mustard are not hues, because they are not the basic forms of color—each is the combination of the three color elements expressed in a marketing name of color. Chapter 4 provides detailed information about hue to help you master its fine points.

Value

Value describes the lightness or darkness of a color. Quilters often classify light fabrics as pastels, while darks are often called jewel tones. Chapter 5 provides detailed information about value to help you tame this tricky beast.

Intensity

Intensity describes the brightness or dullness of a color. Quilters naturally tend to gravitate toward either bright fabrics or their quiet, dull counterparts, but there's a painless way to break out of your intensity rut and I'll show you how. Chapter 6 describes the fine points of intensity and can help you broaden your fabric choices.

Breaking Down a Color into the Three Elements

When breaking down colors into their three elements, it's standard protocol to begin with the biggest element—hue—and work down to the subtlest element—intensity. It's a matter of precision, not preference or priority. Consider pink.

Pink, in quilting circles, covers a lot of territory. It ranges from the bright neon to the classic bubblegum color seen in so many quilts from the 1930s. But there is no hue bearing any version of the name of pink on the color wheel. Instead, we look on the color wheel to find the source or root hue from which pink is derived—red.

Value

Intensity

Then we identify pink's value. Think of gradations of lightness or darkness of color. Your options are light, medium, and dark. Our pink is a light red.

Then we identify its intensity or degree of brightness. Your options for brightness are bright, medium,

and dull. Our pink is dull. It's not boring—I'm just being honest—and some quilt somewhere will be happy to have this pink as part of its color palette.

So, in color wheel terms, our pink is really a dull intensity, light value red. Madison Avenue advertising executives would cringe at the thought of using this term to describe something. It's nowhere near as sexy a name as wild rose, but it nails down the color's characteristics. When you need to find this color in a fabric, knowing the color's characteristics can help you to search for and find your perfect fabric. You're much more likely to find someone who can help you locate the dull intensity, light value red fabric of your dreams than the wild rose of your dreams. After all, your idea of wild rose and my idea of wild rose might be very different.

Table 3.1 Each element of color is relative to those around it

	Hue	Value	Intensity
Definition	Color in its most basic form	Lightness or darkness of a color	Brightness or dullness of a color
Appeal to Your	Emotions	Intellect	Personality
Role in a Quilt	The fun part. Choose colors based on personal preference, quilt's recipient, or many other factors.	Defines the quilt design. Essential to showcase piecing and foreground vs. background.	Gives energy or calmness. Quilters inherently gravitate toward either brights or dulls.
Contrast	Six color harmonies each have differing amount of contrast, depending on how close the colors are on color wheel.	Contrasting values are opposites on a value wheel; similar values are close together.	Contrasting intensities are opposites on a value wheel; similar intensities are close together.

Realize that color is a relative thing. It depends on what's near or surrounding it. A dull pink might be the brightest color in a Civil War Reproduction quilt, but it would surely be a wallflower in a little girl's quilt amid bright yellows, violets, and greens. How a color is perceived is completely dependent upon the other colors in that particular quilt.

The three elements of color, and especially the number one rule of color elements—relativity—are highlighted in Table 3.1.

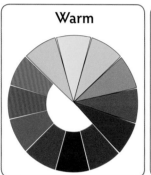 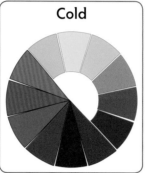

Understanding a Minor Element in Color Relationships

A fourth element can have an impact on color relationships. That element is temperature. Warm yellows, oranges, and reds are on the right side of the wheel, while cool violets, blues, and greens are on the left. A color's temperature appeals to our emotions: warm colors give energy and excitement to a quilt, while cool-temperature colors can calm down other colors in the quilt.

Using the Color Wheel in a Completely New Way for Quilters

Quilters using the color wheel isn't exactly breaking news, let's be honest. What is completely new and different about this book's approach to using the color wheel is its equal emphasis and priority to each of the three elements of color. To make optimal use of the color wheel and really master what it can do for your quilts, you have to understand the finer points of value and intensity just as thoroughly as you do hue. Unlike other books that subtly or not so subtly play favorites with one of these elements over the other two, I have endeavored to provide comprehensive information about each of these essential components equally. I didn't take this approach just to be different; I did it because it's critical to understanding how to make the most of the color relationships in your quilts. In fact, for every project included in this book, I give a chart that lists the major hues, values, and intensities. This chart is your road map to success for each one, and empowers you to approach each future quilt's color palette possibilities intelligently.

Are you scratching your head and wondering where all this going? Are you looking online for a source of color wheels? Don't worry. The following chapters provide instructions on how to make color wheels for each of the three elements, using the fabrics in your current stash. Don't skip these exercises in favor of going straight to the quilt projects. You're supposed to be learning, remember? Think of chapters 4 through 7 as personal training for stash management. By completing these fabric workouts, you'll be getting yourself in shape and making yourself ready to design your own color schemes using the fabrics you already have.

Top Ten Stash-Building Tips

1. Know your stash.
Create color wheels for hue, value, and intensity to discover what fabrics are plentiful and help you identify those that are missing from your stash.

2. Shop for all three color elements, not just hue.
Shop for lights, darks, brights, and dulls as much as you do for the hues that appeal to your heart.

3. Select fabric you can use in multiple ways.
Marbled solids, batiks, checks, plaids, stripes, ethnic prints, and large prints are versatile and can fill many purposes in a quilt. They are equally at home in a pieced quilt, appliqué, borders, and bindings.

4. Frequent a variety of fabric shops.
Certainly be loyal to your local quilt shop, but realize no one location has everything. Fill in the gaps in your stash by shopping regionally, by mail-order, when on vacation, and online.

5. Swap fabrics with friends.
Some of the most versatile fabrics I own came from friends' stashes. They saw the potential in fabrics I would have passed by. Swapped fabrics can be great rut-busters.

6. Encourage family and friends to wrap birthday and holiday gifts in fabric.
My husband and children do this for me and I'm delighted by the bonus of receiving this extra gift on special days in my life.

7. Turn your challenges into opportunities.
You don't need an enormous stash to make stunning quilts if you follow the ten principles in this book. I live in a rural mountain area with limited fabric shopping venues, yet I still manage to make an eclectic variety of gorgeous quilts with ordinary fabrics.

8. Buy long.
I heard Mary Ellen Hopkins say this at one of her famously funny lectures, and I've never regretted her advice. If you love a fabric, you'll find multiple ways of using it over and over again. Some of my favorite fabrics are ones I bought from quilters who had no idea how to use them.

9. Discover fantastic bolts on the sale rack.
Don't bypass those clearance bolts. Many of the fabrics I buy at full retail price eventually end up there because many quilters are unsure of what to do with those unique fabrics. A shop near me runs an end-of-the-bolt sale on the last day of the month, and if you buy what's left on the bolt, you get a great price. I've snapped up yards of extraordinary fabrics from sale racks. Just because someone else doesn't see potential in a piece of fabric doesn't mean it's not there. Look again, especially after you've mastered using the color wheel.

10. Cultivate a relationship with shop owners.
Get to know your local shop owner and tell her what you're looking for and willing to buy. Quilt shops carry fabrics that move quickly; the key to staying in business is constantly offering a new selection of fabrics that keep quilters coming back. Let shop owners know you want fabrics that span a variety of color elements and then be sure to buy them when the shop begins carrying them. The more you buy, the more they'll likely stock to keep you coming back and, with any luck, accompanied by your quilting buddies.

KNOW THIS:
The secret to striking color in quilts is the effective interaction of hue, value, and intensity.

THINK ABOUT THIS:
What has kept you from mastering the color wheel?

DO THIS:
Get out your color journal and get ready to perform the exercises in chapters 4 through 7.

Mastering Hue—
The Celebrity Element

Hue is the star of the color show. For a quilter, hue is why you buy fabric. Quilt shops arrange their fabric bolts by hues. You search for fabric by hues. Hue dominates—but should not rule by itself—a quilter's decisions about fabric.

Hue is the name of a color in its most basic form, without any reference to how light, dark, bright, or dull it is. I call hue a color's roots: if colors had a family tree, the twelve hues on the color wheel are where they would all begin.

Hue is the element in color relationships that gets most, if not all, of the attention. Like the lead actor in a film, hue has the showcase factor that demands people to take notice. Our reaction to hue is emotional. Hues we adore draw us into a quilt for a closer look; they take our breath away. Intellectually, we recognize the quilt's design, the value that defines that design, or if the quilt is bright and cheerful, but it's the hue that makes us love a particular quilt or pass it by.

Using the Color Wheel to Master Hue

The color wheel can help you to master hue by encouraging you to see and use hue more effectively. Remember, the objective is to use the fabric in your stash—those ordinary, everyday fabrics you already own—to create impressive results. The first step in this process is to look at the fabrics in your stash with an artist's eye, to see their true hues.

EXERCISE

Identifying Hues from Fabric Swatches

It's tempting to continue to use those lovely evocative marketing names for fabrics rather than calling them just plain blue. Sometimes, though, adopting a new habit requires giving up a bad habit. Learning to use the correct hue name is the first in a series of steps to accurately identify colors for quilts. Look at these swatches, then go back to the color wheel on the inside covers of this book to figure out their source hues.

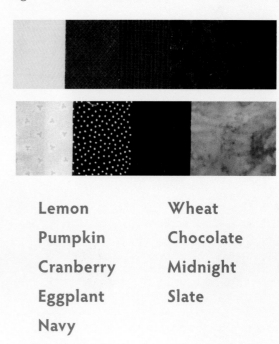

Lemon	Wheat
Pumpkin	Chocolate
Cranberry	Midnight
Eggplant	Slate
Navy	

Creating a Color Wheel from Your Own Fabric Stash

This is where it all begins. The color wheel. Why don't I encourage you to go out somewhere and buy a color wheel? Because you'd miss out on gaining the knowledge of correctly identifying colors, especially the ones in the fabrics you already own. By creating your own color wheel, you'll establish a foundation of knowledge about hue and the contents of your stash. I bet you have fabrics in your stash you don't even remember buying or swapping. Creating your own color wheel can help you to see which hues are present in overabundance, which ones you're lacking, and those you are uncomfortable working with. While you don't need to have every hue in your stash, doing this exercise can help you to become aware of those gaps in your stash and spur you to fill those vacancies on your next fabric shopping excursion. As if you needed an excuse!

Let's start by photocopying the color wheel chart on page 23. It's a good idea to make several copies of the chart so you can be prepared to make additional color wheels when you're ready to experiment with your stash. Here's how to go about making your own color wheel:

1. Start with the colors on spaces 12, 4, and 8. These are the easiest colors to identify and the ones you most likely to have in your stash. They are yellow, red, and blue. Cut out a swatch of fabric from each of these three colors and place it in the corresponding position on the wheel in your color journal. Don't paste them down just yet. You may change your mind about these hues as you continue with this exercise.

2. Now repeat Step 1, but this time find fabric in your stash to match the colors you see on spaces 2, 6, and 10 in the book: orange, violet, and green.

3. Repeat the process of finding fabric and filling in the remaining spaces 1, 3, 5, 7, 9, and 11: yellow-orange, red-orange, red-violet, blue-violet, blue-green, and yellow-green. These colors are more challenging to identify and the ones you are most likely to have gaps in. If you can't find the perfect color, put your best guess in its place. Don't get hung up on getting the precise hue; it's more important to see a progression of hues around the wheel, moving from yellows to oranges to reds to violets to blues and finally to greens.

4. Once you're happy with your fabric swatches, affix them to the page in your color journal using a glue stick or double-sided tape.

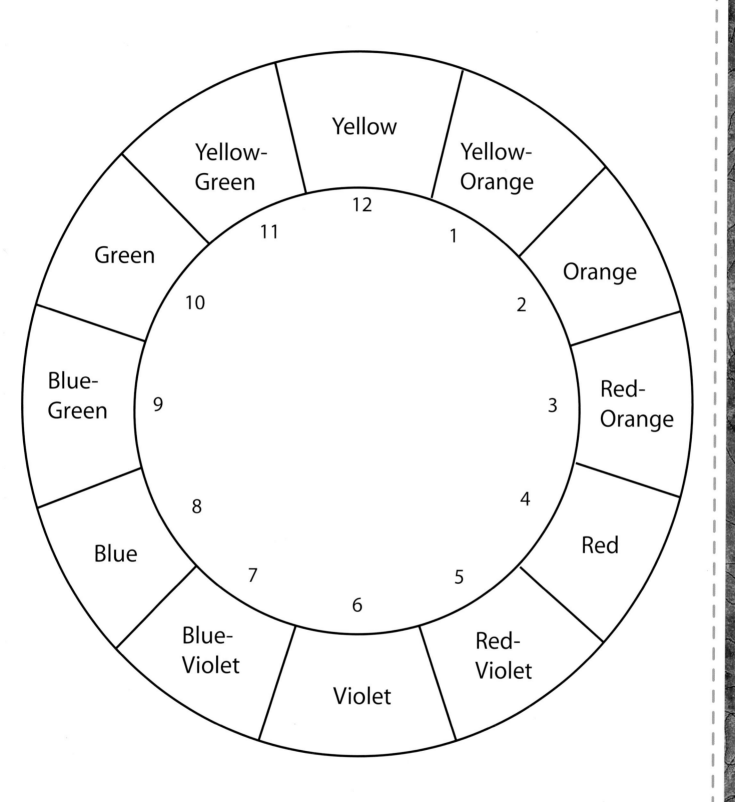

What if I Don't Have all the Hues in my Stash?

If you are a relative newcomer to quilting and don't have an extensive stash yet (what are you waiting for!?) or find that you are missing some hues, I suggest you pull out one of the mail-order fabric catalogs that have lots of fabric photos and cut out appropriate swatches from those. That way you can still fill in your color wheel and make a mental note of what hues your stash "wants" to collect the next time you're in the quilt shop. Also take a look at my Top Ten Stash-Building Tips on page 19.

Realize that your color wheel will look completely different from another quilter's wheel, unless you happened to purchase exactly the same collection of fabrics as someone else, and how likely is that? Quilters run the gamut of tastes and budgets. You actually want your color wheel to be different from everyone else's in your quilting circle. Your color wheel is like your fingerprint: it's your unique imprint on your quilts. Once you've completed the exercise of building your color wheel from your stash, you have a snapshot of the twelve hues of fabric your stash contains today. In a month or two, after you've completed several purchases or swaps of additional fabrics, your subsequent color wheels will likely look rather different. Ideally, they should be more complete.

Variation: Creating Color Wheels for Different Fabric Designs

As a painter, I've done dozens of color wheel painting exercises. I do the same sorts of exercises as a quilter. I don't stop at just one color wheel: I do one for each of the different types of fabrics in my stash. This sort of exercise challenges me to identify hues in various fabric collections. Most fabric color wheels are done with solids, as hue is most easily identified in them because there are no distractions. Once you've created your basic color wheel, I encourage you to make another one (or more) for hand-dyed fabrics, prints, checks, stripes, batiks, reproductions, or your favorite fabric collections. It's a good way to hone your skills at identifying hues and a great way to keep track of what's in or missing from your stash.

ARTIST'S SECRET:
The Key Behavior of Outstanding Artists

What makes one quilter an outstanding colorist and leaves another quilter struggling in the brilliant illumination of her Ott Lite? Elite performers in any pursuit follow structured learning and training processes to achieve their mastery of trades of their craft. I've combined my experience as a quilter, watercolorist, and instructional designer to create exercises in this book that can help you to hone your color vision. Mastering color is a lengthy journey, and not an overnight

junket; nevertheless, the trip can be enjoyable. Every time you complete a color exercise in this book, you've taken one step toward becoming more successful, more knowledgeable, and more experienced with color. A color master.

Where are Black, White, Brown, and Gray?

Astute color students will notice the conspicuous absence of several colors from the color wheel. Black, white, brown, and gray don't appear on the color wheel at all. Why not? These colors don't follow the same rules as the ones on the wheel, and really deserve their own classification. These colors are neutrals; the neutral hues don't have an impact on other hues in a color palette. They are meant to blend in and be unobtrusive. Here are some tips for working with each of the neutrals:

White

The classic quilter's color choice for contrast and appliqué backgrounds, white delivers immediate contrast in a quilt. White demands your attention by drawing your eye directly to it and the design it defines. White works quite well in two-color quilts, such as blue and white, because white is a strong color that can serve as a balance to the brightest and busiest of fabrics. However, if you are including lots of colors in a quilt, you might not want to add an attention hog like white to the mix. In a quilt with lots of colors, white draws the eye away from your other colors and designs. For this reason, experienced quilters with a good eye for color learn to carefully plan whether and where to include white in the mix.

Black

Black is a high-energy color. It can do one of two things, depending on the other colors around it:
1. Energize a limited or dull palette
2. Calm down a high-energy palette

Have you ever seen appliqué worked on a black background? Those appliqués practically leap off of the quilt because they are so full of intensity compared to the black background.

But just as black can serve to enliven a dull or muted pattern, it can also tone down a quilt with lots of busy fabrics, such as the Bejeweled Princess quilt. A black mask around lots of busy, intense fabrics give the quilt focus and serenity.

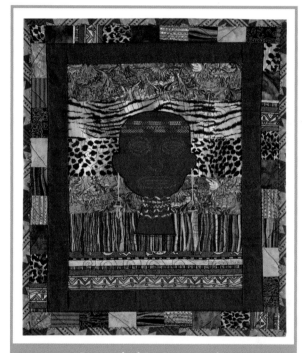

Bejeweled Princess Quilt
17x20". Made by Maria Peagler. Black calms a busy, bright collection of fabrics in this quilt.

Gray and Brown

Both of these hues are combinations of other colors and there are infinite ways of mixing these colors. Grays can be blue and orange mixed together, while brown can be red and green. The way I approach brown and gray is to look at the color closely and try to identify its source hue. Is it mostly red, blue, or yellow? If I'm using a brown that is mostly red, then I treat it as a red on the color wheel.

What if you can't identify the source hue of a gray or brown? Some browns and grays are almost impossible to break down into their source hues, and for those, simply consider them neutrals that don't affect the other hue relationships you have in your quilt. They add to the quilt's color palette, but don't really change it in any major way. The neutrals do, however, have an impact on value relationships. Value relationships are the main topic of Chapter 5, so let's not get ahead of ourselves. For now, it's enough to understand that, when possible, it can be beneficial to identify the source hues of brown or gray, if you can, and treat them as their source hue.

ARTIST'S SECRET:
The Impressionists' Surprising Use of Neutrals

The Impressionist painters didn't use black, brown, or gray on their own. Why not? Because they considered these colors to be incomplete color ideas. Instead, they combined other colors and used them as substitutes. Dull reds stood in for browns, while violets and blues took the place of grays. The next time you visit a museum or come across a high-quality art book, look at the Impressionist paintings and see if you can find any neutral colors. What I bet you'll see is more vibrant hues in their place.

To demonstrate how the Impressionists used "complete" colors instead of neutrals, I created a small

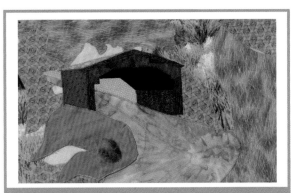

Covered Bridge Quilt
10x15". Made by Maria Peagler. I used dark value reds as a substitute for the actual dull browns on this bridge to push the color in this quilt

quilt that represents a covered bridge in the Appalachians. In reality, the bridge is a dull brown, which I found uninspiring. Instead, I substituted reds for the brown hues in the quilt. From a distance, these components of the quilt look like brown, but up close, you can see they came from some of the red bolts of fabric in the quilt shop.

Discovering the Six Color Harmonies

A color harmony is a prescription for color relationships that work well together. Each color harmony has a different effect, and you can apply each color harmony to any color on the wheel. That's the big secret to successfully using the colors you like with other colors. I'm not trying to tell you to stop using your favorite colors; I'm trying to get you to consider expanding your horizons by figuring out how your favorite colors can work in concert with others. That's the fun part. You get to discover how your favorite colors play with all the others. Color harmonies are pretty much guaranteed to work, as they have throughout time in works of art by the Great Masters. Six main color harmonies that are effective for quilters are:

Analogous

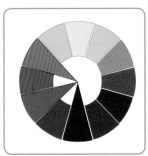

Analogous colors are the two to five colors next to each other or close together on the wheel. Analogous colors are similar, and therefore work well together, but also have little contrast. Analogous colors don't have to be adjacent to each other: as long as they are within five spaces of each other in either direction on the color wheel, they're still considered analogous. It doesn't matter where on the color

wheel you start—two to five colors in either direction are analogous to the one from which you started. Analogous color harmonies have the least amount of contrast of all six color harmonies. If the colors you love fall into an analogous relationship on the wheel, you can achieve more contrast by relying on value and intensity, which are discussed in greater detail in chapters 5 and 6. Chapter 8 includes an analogous quilt project, so you can see for yourself how analogous colors play well together.

Complementary

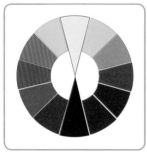 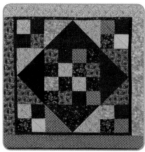

Complementary harmony results from combining two colors that are found opposite each other on the wheel. Complementary colors have high contrast, so they are easily used to achieve quilt block definition or shapes in an art quilt. If you're using complementary colors and find them too jarring, you can tone down your quilt by using similar values and or duller intensities. The Complementary quilt project is included in chapter 8.

Triadic

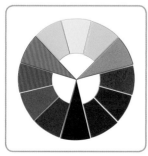

Triadic harmony is accomplished by combining three colors from around the wheel, each positioned four

spaces apart. Regardless of where you start, as long as you choose three colors positioned four spaces apart, the colors will work together. This is a medium-contrast recipe that does a lot of the work for you. By selecting this harmony, you get a great variety of colors with just enough contrast in your quilt. Like the Analogous and Complementary harmony recipes, it doesn't matter where you start counting on the color wheel; as long as you count four spaces in either direction, the colors will work together in medium contrast. Chapter 9 includes a Triadic quilt project.

Split-Complement

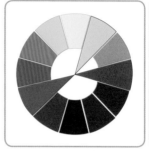

Split-Complement harmony is achieved by using one color of your choosing plus the two colors on either side of its complement. Huh? I know, it sounds confusing, but it's really not. Look at your color wheel and we'll walk through this together. First, pick a color, let's say blue. Now find its complement—its complement is located directly opposite, and blue's complement is orange. Now go one color clockwise and one color counterclockwise (that's the split part) from the complement: those colors are yellow-orange and red-orange. So, the Split-Complement harmony here is blue, yellow-orange, and red-orange. Split-Complement harmonies are another medium-contrast color recipe that make you look good every time. You get a pleasing level of contrast without it being overly drastic. There's a Split-Complement quilt project in chapter 9, so you can see how well this tried-and-true recipe works.

Double-Complement

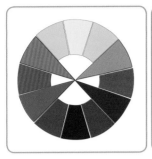

Double-Complement harmony is achieved by using two sets of complementary colors. For example, if you look at your color wheel, you'll see that red and green are complements and blue and orange are complements. Combining these four colors in a quilt would result in a quilt with Double-Complement harmony (red/green and blue/orange). Double-Complement harmony is a higher-contrast color recipe, but because it has more colors, it has less contrast than a normal Complementary color recipe. That's right: the more colors in your quilt, the less importance and focus each one has. chapter 9 includes a Double-Complementary quilt project so you can prove to yourself that I'm not making this up as I go along.

Round-Robin

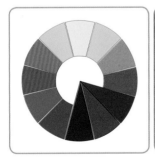 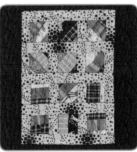

Round-Robin harmony is a variation of Analogous color harmony. Round-Robin starts with one color and uses increasingly smaller amounts of each successive color around the wheel. This is a fun palette that works well every time. Just pick a place on the color wheel and go around the wheel, using less of each hue as you move farther and farther away from your starting color. chapter 9 includes a fun little Round-Robin quilt project.

Making Color Harmonies from Your Stash

Are you ready to get started? Can you simply not wait for the quilting projects in chapters 8 and 9? I understand completely! Would you like a quick little taste of how color harmonies work? This exercise is intended to provide you with a visible map of how each color harmony works with the fabrics in your stash. It's instant gratification, and a real eye-opener. We're going to fill in the table on page 29.

1. Start by selecting your main color. I suggest you select a color you like and have used many times. That's going to be your starting fabric for all of these color harmonies. After all, many of us get an idea for a quilt after seeing a fabric we absolutely must have. So let's start there.

2. Cut out six swatches of your main fabric. Affix one swatch of your main fabric in the sample fabric swatches space for each using your trusty glue stick or double-sided tape.

3. Create each color harmony by using your main fabric as the starting point and selecting colors that follow the recipes outlined above. In doing my own chart, I chose blue as my main fabric. Blue's complement is orange, so I put that in the complement space. I could have chosen from many colors for Analogous, but I chose blue, green, and violet. Continue down the chart, creating each harmony by affixing the appropriate fabric swatches for each type of harmony.

Table 4.1 Six color harmonies

Color Harmony	Description	Sample Fabric Swatches
	Analogous harmony is achieved by using two to five colors close to each other on the color wheel. The result is a low-contrast harmony that blends well.	
	Complementary harmony is achieved by using two colors opposite each other on the color wheel. The result is a high-contrast harmony that provides great definition for design elements such as quilt piecing, appliqué, and separating foreground and background.	
	Round-Robin harmony is an Analogous harmony that contains lesser amounts of each successive color. The result is a low-contrast color harmony.	
	Triadic harmony is achieved by using three colors spaced evenly apart around the color wheel (four spaces apart). The result is a medium-contrast harmony that's successful every time, no matter which three colors you use.	
	Split-Complement harmony is achieved by using one color, plus the two colors on either side of its complement. The result is a medium-contrast harmony that always works well, regardless of the starting color.	
	Double-Complement harmony is achieved by using two pairs of opposite colors on the color wheel. The result is a higher-contrast color harmony that has more colors than a normal Complementary harmony and generates less focus on each color.	

ARTIST'S SECRET:
Capitalizing on the
Three Bears Rule of Color

Painters know this rule and now you do, too: using variable amounts of color in your quilts gives them a more complex, sophisticated look. In other words, something's got to be predominant.

Using the same amount of two or more colors makes their relationship static and predictable. Instead, use a large amount of one, a smaller amount of the next, and even less of the third. The Round-Robin color harmony automatically does this for you. [iv]

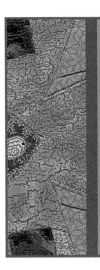

KNOW THIS:
Hue is the most basic form of a color.

THINK ABOUT THIS:
What hues did you have trouble identifying in the color wheel exercise?

DO THIS:
Build a color wheel using the fabric from your stash. Make one for solids, then another for prints, a third for batiks, and so on. Practice makes perfect and it's a great way to generate an inventory of your stash!

[i] Sharp Brains Blog, http://www.sharpbrains.com.

[ii] Ott Lite is a registered trademark of Ott-Lite Technology.

[iii] Lee Boynton and Linda Gottlieb, *Painting the Impressionist Watercolor* (New York: Watson-Guptill, 2004).

[iv] Greg Albert, *The Simple Secret to Better Painting* (Cincinnati: North Light Books, 2003).

Mastering Value—
The Workhorse Element

The second element of color, value, represents the lightness or darkness of a color. Everything in effective quilt design hinges on proficient use of value. While hue may appeal to our hearts, value appeals to our heads, helping us to recognize a Bow-Tie block, a flower in an art quilt, or a great border or binding around a quilt.

Using different values is the simplest way to create contrast in a block design. Have you ever heard the saying, "Color gets the credit but value does the work?" No? Well, you just did. I equate value to baking powder in a chocolate cake: after taking a bite of a particularly decadent chocolate cake, nobody ever says, "Wow! Great baking powder!" You can bet they'd surely notice what a flop the cake was if you inadvertently omitted that one little ingredient. Baking powder is an essential, often underappreciated, ingredient—just like value. Learn how to successfully use value and your quilts will really stand out. There's a reason why they award blue ribbons for both chocolate cakes and quilts at fairs.

Using the Color Wheel to Master Value

Until I really understood value, I never thought of pink in terms of a red hue. It was just pink. Doing color exercises helped me to see the enormous range of values in my stash and how they related to their source hues. I used to have my fabrics organized mostly by color, but also by collections. I changed that once I became a color master: I organized my stash first by hue, then loosely by value in light, medium, and dark arrangements.

Identifying Values from Fabric Swatches

Remember those colors whose hue you identified in Chapter 4? It's time to identify their values. As a reminder, your options for value are light, medium, and dark.

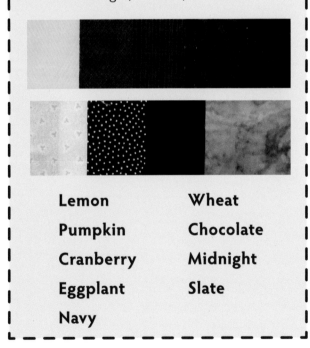

Lemon	**Wheat**
Pumpkin	**Chocolate**
Cranberry	**Midnight**
Eggplant	**Slate**
Navy	

I didn't get compulsive about it, so it wasn't a chore; rather, reorganizing my stash helped me to see the big picture of what values were in my stash and in what quantities. Knowing how much you have is as important as knowing what you have.

My quilts improved dramatically once I learned to see the fabrics in my stash the way an artist sees

color: by first seeing hue and then seeing value. I bet you'll realize a dramatic difference, too, once you learn to recognize hue first and value second. You'll see the fabrics in your stash in an entirely new way. You may not be inspired to reorganize your entire stash, but that's okay. If you can see the hues and values, the organization doesn't matter. In this exercise, you'll be creating a value wheel, similar to a color wheel that you built in Chapter 4.

Why do you need a value wheel, you ask? And what exactly do you *do* with a value wheel?

First, as you select the fabrics for your value wheel, you are training your eye to see color in fabric as an artist does. Not only do you recognize hue, you now recognize value as well. It's good practice. Remember, in order to become a habit, you need to practice new skills. Second, as you flip through the fabrics in your stash, you get a snapshot of the values it contains and, more importantly, the ones that are missing. By recognizing those values your stash is lacking, you'll be able to make a mental (or physical) note to yourself to look for those the next time to visit the quilt shop. I actually shop for value as much as or more than I do for hue. And you'll probably begin to realize that most shops carry mediums, a few darks, and even fewer lights. This is why it's important to frequent several shops in your search for fabrics.

ARTIST'S SECRET:
Why is it so Difficult to Find Light Fabrics?

We've been told over and over again that we quilters don't have enough light values in our stashes until we believe it's a character flaw. You want to know why quilters' stashes aren't awash in light fabrics? It's because few quilt shops carry them, and that's because fabric manufacturers don't make many light fabrics. Fabric manufacturers sell to a worldwide

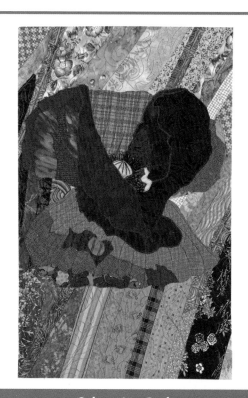

Ode to Joy Quilt
17x27". Made by Maria Peagler. Using a value wheel was essential to defining the petals of the poppy. Without enough value contrast, the petals would disappear into one sea of red.

market, not just the United States, and pastels simply don't sell well in other areas of the world. So, as the world gets smaller, the tastes of quilters internationally affect what is available to you locally. Still, you can ask your quilt shops to carry more light fabrics, and if they manage to find them, be sure to buy them.

Third, you become your own value coach, fine-tuning your color vision to recognize what light, medium, and dark actually look like in different fabrics and hues. Sure, the easiest fabrics to do this with are solids, but try it with prints, plaids, and stripes, and you'll really be flexing your creative muscles and educating your eye to recognize value, regardless of fabric design. I bet you'll notice a difference when you make your next quilt, as you'll be much more in tune with value. When I was learning how to paint with watercolors, I did

exercises like these until I could do them in my sleep, and while it may seem like drudgery at first, your color palette development skills will be much stronger and your quilts will be more beautiful because of it, all because you became more competent at using the fabrics you have already.

Fourth, you can also use a value wheel when selecting fabrics for your quilt. If you need lots of contrast and you have mostly mediums in your quilt, use the value scale to decide if lights or darks from your stash will give you the best contrast. Place your fabrics next to your value scale and see where your

mediums fall, then try to select fabrics opposite those on the wheel for greater contrast.

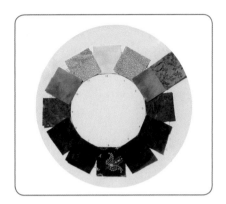

EXERCISE

Creating a Value Wheel from Your Stash

Have you ever heard of a value wheel? Neither had I, until a couple of years ago, and now I can't imagine designing a quilt without it. A value wheel is similar to the color wheel: it contains twelve values set out in a clock shape. But a value wheel doesn't contain twelve different values. As quilters, we must regrettably admit it would be almost impossible for us to walk into a quilt shop and find twelve values of the same hue. Instead, the value wheel uses seven values ranging from light to dark and back to light again. The value wheel is actually a left-to-right mirror image of itself. Photocopy the value wheel on page 35. Notice it's the same as the color wheel, simply without the color labels.

Follow these steps to create a value wheel using your own stash:

1. You will need to cut plenty of swatches for this exercise, so start cutting. You want swatches that represent the entire range of values —lights, mediums, and darks—of one color in your stash.

2. Begin by positioning swatches at spaces 12 and 6 on a 12-space wheel. Space 12 will hold your lightest value and space 6 will hold the darkest value. Those are the easiest to identify and we'll go from there.

3. Now select two swatches from the medium-value fabric and place them in spaces 3 and 9. These spaces are now mirror images of each other, as will be the remaining spaces on the wheel.

4. Now fill in the value spaces between light and medium—spaces 1 and 2, and their mirror images at 10 and 11. These values are more challenging to identify and the ones you most likely won't be able to fill from your stash. If you can't find the perfect value, put your best guess in its place. Don't get hung up on getting the precise value; it's more important to see a progression of value around the wheel, moving from lights to mediums.

5. Now fill in the medium to dark value spaces—spaces 4 and 5, and their mirror images at 7 and 8. Your value wheel is now complete, even if some of the spaces are filled with colorful paper images of fabric clipped from catalogs.

6. Once you're happy with the arrangement of value swatches, affix them in your color journal using your glue stick or double-sided tape.

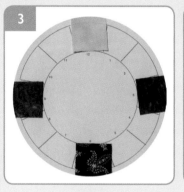 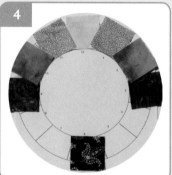 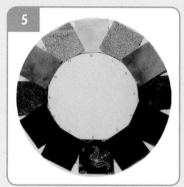

Remember the secret to understanding the color wheel? The same principle applies to the value wheel. The closer two values are on the wheel, the more alike they are, and the less contrast they have. The highest contrast occurs between values directly opposing each other on the wheel.

What if you're not ready to leap into building a full-fledged value wheel? First, don't beat yourself up about it. You don't fail Color Mastery 101 if you're not yet confident enough to take on the value wheel. Start with small steps at first, and eventually you will be ready to tackle that wheel. Until then, you can create a value scale with only three values: light, medium, and dark. Try this:

1. Cut swatches from the light, medium, and dark values of the color of your choice, and affix them to a value page you create in your color journal.

2. Do this again for another color, so you can identify values in your stash using various colors . I recommend creating a value scale for several colors in your stash, especially yellow, blue, and red.

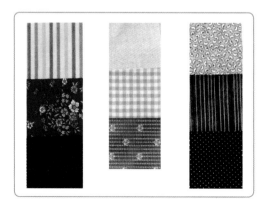

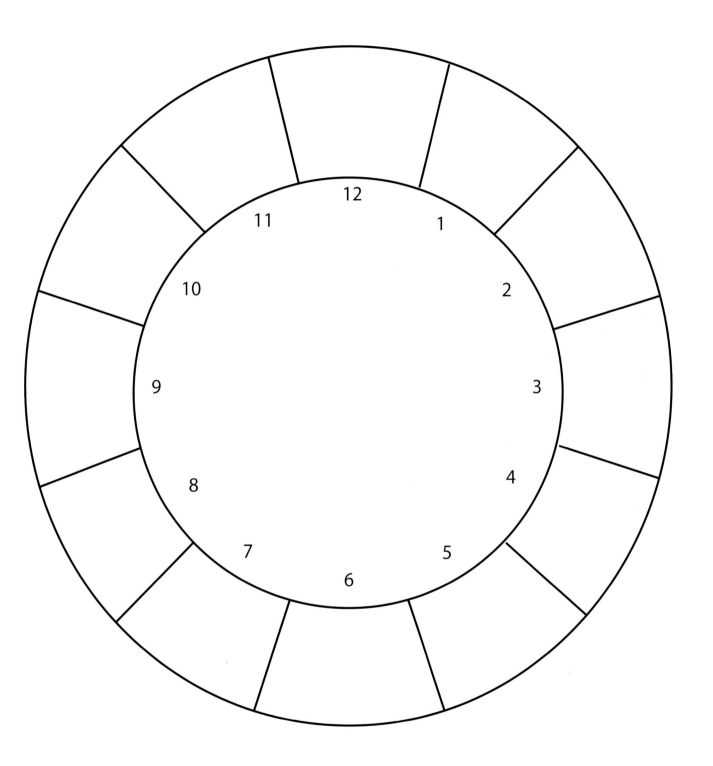

ARTIST'S SECRET:
How to Successfully Use Yellow

Many quilters shy away from using yellow, but here's a tip to using it successfully: try a darker value yellow. It's less intense and won't overwhelm the other colors in your quilt!

KNOW THIS:
Value is essential to distinguish a quilt's design.

THINK ABOUT THIS:
How can you find a greater range of values in fabrics?

DO THIS:
Build a value wheel for several colors using only the fabric in your stash.

¹ Weeks Ringle, *Becoming Fabric*, WhipUp, http://whipup.net/2006/09/25/becoming-fabric/, Sept. 25, 2006, November 27, 2007.

CHAPTER SIX

Mastering Intensity—
The Best-Kept-Secret Element

Intensity, the third element of color, represents the brightness or dullness of a color. By dull, I don't mean boring, unattractive, or the kind of monotony that blankets me as I watch the fishing channel on television with my husband. Sorry, babe. Instead, while a brightly colored fabric practically leaps off the quilt and demands your attention, a dull-colored fabric blends into the quilt, rarely ever getting noticed. If you've ever participated in a quilt guild challenge, you know a favorite experiment is to dole out the bright fabrics and see quilters cringe at the thought of working with them to develop an appealing design.

Intensity is the mystery ingredient that makes people sit up and take notice, usually without knowing quite why. A variety of intensities in a quilt provides visual complexity and a richness that people find hard to explain; often times, they'll claim to detect the great use of color in your quilt. People may not be able to verbalize exactly what makes a quilt look so stunning, but they will be mesmerized by the quilt's effect.

To continue our recipe analogy from Chapter 5, have you ever heard of chocolate cakes made with outrageous-sounding ingredients, like mayonnaise or Coca-Cola? They sound odd, but the results are outstanding; those secret ingredients lend a certain special something that elevates the finished product above its peers. Intensity works the same way. If you can master using this one element of color, you will have other quilters asking, "How did you do that? I use the same colors and my quilts don't look like that!"

In my color classes, I've noticed that, more than with any other color element, personal preference governs the fabric intensities quilters habitually use. People inherently gravitate toward either brights or dulls, calling themselves "whimsical" or "high-energy" if they like brights, while labeling themselves "earthy" or "country" if they favor dulls.

Novelty prints and children's fabric often use bright colors, while reproduction and 1930s fabrics often use dulls. Intensity contributes to the mood of a quilt, with bright fabrics creating a dynamic, bold quilt; dull fabrics contribute to an antique, sweet, or quiet quilt.

I encourage quilters to acquire fabrics outside of their normal intensity preferences so they can challenge themselves to create a quilt with different color, value, and intensity combinations from the ones they always use. Think of it as gathering and using the tools necessary to break out of a rut. Even the simplest of quilt designs and color harmonies can look sophisticated with a pinch of this mystery element.

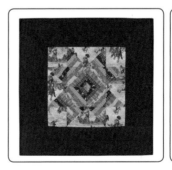 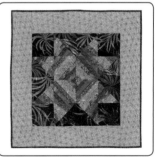

Round-Up Star quilt in two versions:
the left with dull fabrics, the right with bright fabrics.

Identifying Intensities from Fabric Swatches

Let's return to the fabric swatches we first used in Chapter 4 to identify hues and in Chapter 5 to identify values. This time, we're going to evaluate the swatches and identify their intensities. As a reminder, your choices for intensity are bright, medium, and dull.

The three color elements—the properties—for each of these colors are:

Lemon: light value, bright intensity yellow

Pumpkin: medium value, dull intensity orange

Cranberry: dark value, dull intensity red

Eggplant: dark value, dull intensity violet

Navy: dark value, dull intensity blue

Wheat: light value, dull intensity yellow

Chocolate: dark value, dull intensity brown

Midnight: dark value, dull intensity black

Slate: dark value, dull intensity blue-green

Using the Color Wheel to Master Intensity

Until I really understood intensity, I never appreciated how much I loved bright colors. I came to realize I had few dull fabrics in my stash and I set about correcting that shortcoming. And it took some work, let me tell you. I found I frequented fabric shops that carried bright fabrics and didn't shop much in the others. I really had to transcend my normal shopping routine to expand my stash's intensity range.

How to Use an Intensity Wheel to Create a Visually Rich Quilt

Creating an intensity wheel further develops your color vision, encouraging you to transcend the traditional stand-bys of hue and value, where most quilters' color competencies stop. By taking the time to assess your stash and create an intensity wheel, your eye will practice identifying and categorizing all three color elements so you can supercharge your color repertoire.

Intensity is yet another way of creating contrast in your quilt. If your fabric choices are all dull and don't provide enough contrast, try a brighter intensity of a few of the colors. Whether you're that "whimsical," "earthy," or somewhere-in-between quilter, building a more versatile stash will allow you to create more visually interesting quilts through the use of contrast. The intensity wheel develops an awareness of the importance of subtle and not-so-subtle contrast, an element you previously took for granted.

Most importantly, by creating an intensity wheel, you should discover that hue, value, and intensity are intertwined. A light value fabric appears brighter, while a darker value appears duller. A dull, light value yellow can appear brighter than darker value bright yellow. Some colors are also inherently brighter, regardless of their value and intensity. Yellow is the brightest hue, with red a close second.

Creating an Intensity Wheel from Your Stash

Chapters 4 and 5 walked you through the process of creating color and value wheels. Now it's time to create an intensity wheel. The procedure is for creating an intensity wheel is essentially the same as that for creating a value wheel. You can photocopy the same chart from Chapter 5 to use in this exercise. You'll be cutting and pasting twelve fabric swatches in seven intensities, ranging from bright to dull and back to bright again. Like the value wheel, the intensity wheel is a left-to-right mirror image of itself.

Follow these steps to create an intensity wheel:

1. You will need to cut plenty of swatches for this exercise, so start cutting. You want swatches that represent the entire range of intensities—brights, mediums, and dulls—in one color of your stash.

2. Begin by positioning swatches at spaces 12 and 6 on a 12-space wheel. Space 12 will hold your brightest intensity and space 6 will hold the dullest intensity. Those are the easiest to identify and we'll go from there. Position your swatches but don't paste them down yet.

3. Now select two swatches from the same medium-intensity fabric and place them in spaces 3 and 9. These spaces are now mirror images of each other, as will be the remaining spaces on the wheel.

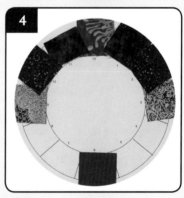

4. Now fill in the intensity spaces between bright and medium—spaces 1 and 2, and their mirror images at 10 and 11. These intensities are more challenging to identify and the ones you most likely won't be able to fill from your stash. If you can't find the appropriate intensity, put your best guess in its place. As with the value wheel, it's more important to see a transition of intensity around the wheel, moving from brights to mediums, than to have every space filled in perfectly. Remember, this is an exercise, not a test.

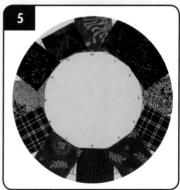

5. Now fill in the medium to dull intensity spaces—spaces 4 and 5, and their mirror images at spaces 7 and 8. Your intensity wheel is now complete, even if some of the spaces are blank or filled with colorful images clipped from fabric catalogs.

6. Once you're happy with the arrangement of intensities on your intensity wheel, affix them in your color journal using your glue stick or double-sided tape.

The clock face of the intensity wheel allows you to easily identify opposite intensities in your fabric swatches. The closer two intensities are to each other on the wheel, the more similar they are, and the less contrast they have. The highest contrast occurs between intensities directly opposite each other on the wheel.

If you don't feel ready to tackle an intensity wheel, create an intensity scale with only three intensities: bright, medium, and dull. Try this:

1. Cut swatches from the bright, medium, and dull intensities of the hue of your choice, and affix them to an intensity page you create in your color journal.

2. Do this again for another hue, so you can identify the three basic intensities in your stash using various colors. I recommend creating an intensity scale for several colors in your stash. If nothing else, it's good practice for your color eye.

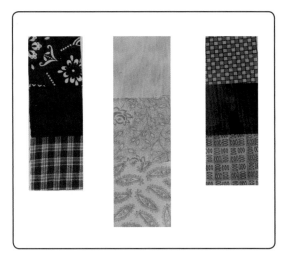

KNOW THIS:
Intensity adds visual richness to even the simplest of quilt designs.

THINK ABOUT THIS:
What fabric intensities attract you most?

DO THIS:
Build an intensity wheel for the various hues of fabric in your stash.

What Every Quilt Needs—The Dance of Harmony and Contrast

Ultimately, we all have the same goal. We want our quilts to be stunningly beautiful. When people look at my quilts, I want them to be mesmerized by the colors and fabrics I've put together, without the quilt looking overly complicated or busy. I don't want them to notice the piecing or the technical precision: I want to have created the perfect marriage of color and design that will knock people's socks off. I don't ask for much, do I?

If it were that easy to knock people's socks off, everybody could do it, right? Well, it wasn't easy for me and there are still plenty of folks walking around wearing socks. It took more than 15 years of quilt making, a lifetime love of color and art, and several years of watercolor painting for me to really understand how to combine those elements into a really outstanding quilt. Lucky for you to have found this book, because I'm about to share those secrets with you and save you years of creating, "Oh, that's pretty," quilts, allowing you—with practice—to leapfrog to, "Wow, that's spectacular," quilts. By reading this chapter and faithfully performing the exercises within it, you should have a better understanding of how to marry hue, value, intensity, and design to make many stupendous quilts.

It's All About the Harmony

Quilting is the fine art of bringing harmony to the mix of fabrics, colors, piecing, and stitching. A harmonious quilt is a really fantastic quilt. Harmony is an elusive concept, one that's often difficult for quilters to grasp, but we know it when we see it. Harmony is an art term that means a balance or pleasing arrangement of the parts. The parts work together well, creating a united look. No one part of the design is overwhelming, out of place, or just plain wrong. In quilter's terms, when a quilt is harmonious, "it works."

Using the six color harmonies outlined in Chapter 4 is a great starting point for achieving harmony in a quilt, but there's more to creating harmony than just putting together a pleasing arrangement of colors. You mustn't discount value, intensity, the quilt's overall design, the fabric style, and the quilting (stitching) design that goes into it. When carefully orchestrated, all of these parts converge to create harmony in your quilt. But sometimes the orchestra is not quite in tune. . . .

We've all seen quilts that don't work, sometimes our own, and rarely can we figure out why right away. It's only after we get some distance or time away from the project that we can understand what went wrong and what we can do next time to correct it. Maybe one fabric totally overwhelmed all the others, or the binding was completely too light, or the quilt didn't have enough contrast and the block design just disappeared. Disharmonious quilts don't work. I find them difficult to look at, even when I know they were created with love and took hundreds of hours to complete. They literally hurt my eyes because their elements are out of balance. We can learn to create harmonious quilts by looking honestly at our own quilts, as well as those of others, with an analytical eye. We must learn what creates harmony and what detracts from it.

Discerning Your Intuitive Harmony Preferences

What kind of harmony do you like? Just like our musical preferences, everyone has different harmony preferences. This exercise is intended to help you define your idea of harmony: the looks that appeal to you and the looks that don't. You will need to gather some magazines, photographs, or clippings containing photographs of quilts, flowers, interior decor, and artwork. Essentially, you're looking for images that contain color. Once you've collected them, you will need to separate those images into two categories: harmonious and disharmonious. Before you can create a harmonious color scheme in a quilt, you need to understand what you do and don't like in colors. The best way to do that is to flood your color journal with images of colors, quilt designs, hand or machine quilting designs, and fabrics you love, along with the ones that really make your skin crawl. I often learn more from the quilts I don't like, since I can tell you exactly what I don't like about them, while it may take me quite some time for me to tell you why I love a quilt besides "it's cute," or "because my friend made it for me."

Follow these steps to discern your intuitive harmony preferences:

1. Gather photos, fabric swatches, magazine clippings, or other sources of color and quilt design inspiration.

2. Look at each one and ask yourself only one question: Is this harmonious or not? Separate the photos into two piles—harmonious and disharmonious. Now label one page in your color journal Harmonious and another page Disharmonious.

3. Select a disharmonious photo and ask yourself what you find unappealing about it. Does it not have enough contrast? Do you not like the hues? Are the values too similar and so the design gets lost? Is one color so intense it overwhelms the others? Is it an odd combination of cool and warm hues? Try to pinpoint which element of color is out of place in the color scheme: hue, value, intensity, or temperature. Paste the photo on your Disharmonious page and list the elements that make it so. Repeat the assessment and listing process with a few of the images from your disharmonious images so you really get the hang of identifying which aspects don't work and why.

4. Now go through the same process, one at a time, for a harmonious photo. Ask yourself why those color combinations are harmonious. What specifically contributes to the pleasing balance of color elements? Paste the photo on your Harmonious page and list the elements that make it so. Repeat the process with a few more images from your harmonious collection. It's good practice!

This exercise will help you train your artistic eye to discern harmonious combinations more quickly and easily when you are putting your own color palettes together. The more you know about what doesn't work together and why, the easier time you'll have identifying the many other possibilities.

Harmony is Subjective

Let's be honest. Harmony is subjective: what I like in a quilt may totally turn you off. I happen to love bright, intense colors, and I find pastels rather unexciting. You may love pastels and think intense colors are garish. Neither of us is wrong; instead, we are both confident in the knowledge of our personal color, design, and fabric preferences. We don't let the latest pattern, friend's quilt, or other influence lead us down a quilt path we know we'll regret or dislike. I'm all for trying out a new style or color scheme, but that's where the color journal comes into play. I always try it out first on a small scale on paper before I commit to it in a large quilt that will hang on my wall.

It's Even More About the Contrast

As important as harmony is to a quilt, contrast is even more important. In fact, the number one design effect that can make or break a quilt is contrast. Without contrast, a block design looks like a hodge-podge of fabrics stuck together with no rhyme or reason. The design gets lost and so does the effect you're trying to create in your quilt. Quilts require varying degrees of contrast: a Mariner's Compass requires more contrast to be successful than does a Roman Stripe. And you better believe if I'm piecing all those sharp points, I want the contrast to really showcase them. I want my efforts to show up big time!

How do quilters achieve contrast? Contrast is achieved by using opposing qualities in the three elements of color: hue, value, and intensity. Now that you've made your own wheels for all three of these elements, you should be able to understand and literally see this concept much better. The easiest way of achieving contrast is to select from opposites on those wheels. Red and green are opposites on the color wheel, and they have the greatest amount of contrast when used in combination with any other colors. Using red with yellow or blue won't result in the same contrast. Generally, the closer hues are on the wheel, the lower in contrast they are.

Same principle applies to value. Consider, using any of the value wheels you created in Chapter 5, the lightest value positioned at space 12 on the wheel; its greatest contrast is represented in space 6, the darkest value. They are located opposite each other on the wheel and have the greatest amount of contrast possible for that color. Move either clockwise or counterclockwise from space 6 on any color's value wheel and you'll be heading toward both greater contrast and the lightest value. Even if you skipped the exercise for creating a value wheel—shame!—you know that light and dark values represent the greatest contrast, while mediums have less contrast with the same color's lights and darks. Mixing a variety of values in a quilt is always a good plan, as it's the value that really makes your design stand out.

Similarly, intensities are at their greatest contrast when opposite each other on the intensity wheel. Intensity is probably the least understood of all three color elements, but it has a powerful effect in a quilt: it can call attention to an area of your quilt that needs it, or it can totally overwhelm the other elements, depending upon on how much contrast you've incorporated. Too much intensity contrast results in an out-of-balance, disharmonious design, while a judicious use of intensity contrast can attract the viewer's eye to a specific location on your quilt.

Table 7.1 Color harmonies in order of contrast

Color Harmony	Description	Amount of Contrast
	Round-Robin harmony is an Analogous harmony containing lesser amounts of each successive color. With little contrast, the colors blend together.	Lowest
	Analogous harmony is the result of using two to five colors close to each other on the color wheel. It yields a low-contrast harmony that blends well.	Low
	Triadic harmony is the result of using three colors spaced evenly apart around the color wheel (four spaces apart). Its balance of medium contrast and color variety could be the perfect combination.	Medium
	Split-Complement harmony is the result of using one color, plus the two colors on either side of its complement. Its medium contrast is balanced by two colors that blend well together.	Medium
	Double-Complement harmony results from using two pairs of opposite colors on the color wheel. It yields high contrast from colors that do not blend.	High
	Complementary harmony results from using two colors opposite each other on the color wheel. This yields the highest contrast from colors that do not blend.	Highest

While walking through my guild's quilt show this year, I came to a realization: the quilts that most appealed to me were the ones that had a variety in intensity. The quilts with less variety of intensity were beautiful, but predictable. The contrast in intensity resulted in a visually richer, more complex quilt, even when the quilt design itself was relatively plain. And most people won't be able to figure out why those quilts appeal to them. Intensity really is the "mystery" ingredient.

Table 7.1 lists the color harmonies and their characteristics according to their relative degree of contrast. You might want to flag this page!

Clever quilters incorporate contrast in temperature between warm and cool colors, although relying solely on temperature can yield unpredictable results. Some artists believe that pleasing color schemes can be made just by using hues that contrast in temperature, but I disagree. I've seen some horribly unattractive color schemes that could have been remedied by a better combination of all the colors' ingredients, not just temperature.

I was in my local yarn shop recently and saw a knitted purse that was made of three large, wide horizontal stripes. The color combination was green, blue-green, and red. According to the guidelines of temperature contrast, that combination should work; the purse used two cool colors plus a warm one, the red. In theory, it worked. In practice, not so much. It looked disharmonious to me. It really hurt my eyes to look at it. I thought about that purse for days, trying to solve the color puzzle and how those elements could have worked better together, until I had that, "Eureka!" moment. Green and blue-green are both cools, so why not use a cooler red? Red-violet is a cooler version of red, since it contains cool violet. I got out some swatches, worked them in my color journal, and lo and behold, it worked much better.

EXERCISE

Creating the Five Types of Contrast

Let's make a contrast page in your color journal:

1. Draw three columns and label them Low, Medium, and High. Now draw five rows across the columns and label them Hue, Value, Intensity, Temperature, and Fabric Style.

2. Experiment with pairs of fabrics and create examples for each contrast type: low, medium, and high. Using your trusty glue stick or double-sided tape, affix them into the table in your color journal. Don't feel you need to fill in the table all in one sitting. This exercise is meant to take awhile. Think about it and feel free to complete it over a period of days. The five types of contrast are pictured on page 46.

Fabric styles are another source of contrast available to quilters. Many quilters are stuck in the "matching" mindset: the colors in the quilt need to match each other, and the quilt needs to match the sofa in the living room where the quilt will eventually reside, so don't even think about using plaids and stripes together in a quilt! In fact, mixing fabric styles can give your quilt a richer appearance and avoid that "paint-by-numbers" look. While fabric style alone won't give you enough contrast for a block design, it can give you a more exciting, appealing quilt.

I intentionally incorporated exercises in this book that will encourage you to see things for yourself instead of just telling you how things work. Each of the exercises you complete helps to sharpen your eye to be more skillful in selecting colors for your quilt. By doing the harmony and contrast exercises, you work artistic muscles that you can flex when it comes time to make your next project. Can you skip the exercises? Sure. Will you really grasp these concepts if you do? All I can tell you is that, when I was learning about color, I learned more by doing the exercises than I learned by reading about the theories in a book.

Table 7.2 Contrasts by hue, value, intensity, temperature, and fabric style

Contrast Amount	Low	Medium	High
Hue			
Value			
Intensity			
Temperature			
Fabric Style			

KNOW THIS:
Color masters achieve both contrast and harmony for stunning quilts.

THINK ABOUT THIS:
What makes a quilt disharmonious to you?

DO THIS:
Start looking at quilts, art, and design and ask yourself intuitively: is this harmonious or not?

Top Ten Color Mastery Tips

1. Develop a creative habit of keeping a color journal and using it often.

2. Discover the hidden potential in your stash by making color wheels for all three color elements. Repeat this exercise often to see how your stash and color preferences evolve over time.

3. Test color swatches for every quilt you want to make. Do it even for quilts you don't want to make. Just do it. It's good discipline and it'll save you the time and effort of making a quilt you won't find visually appealing.

4. Know that hue appeals to your emotions. Value appeals to your intellect. Intensity appeals to your personality.

5. Create your own color vision instead of depending on kits and bundles.

6. Use color harmonies for color combinations rather than matching fabrics to a focus fabric.

7. Don't feel you need to memorize the color harmonies. Instead, post the color harmony chart from this book in a visible place in your studio and refer to it often. A pull-out version is on pages 89 and 90.

8. Recognize that a color is relative to those colors around it.

9. Be courageous. Develop your own color style. Don't just follow someone else's advice or style. Henri Matisse and Pablo Picasso developed their signature styles only after receiving recognition for their traditional artwork.

10. Know your purpose in making a quilt. Every creative decision starts with asking yourself who the finished piece will be for, what the design will be, and how it will be used.

Color Mastery Quilt Gallery

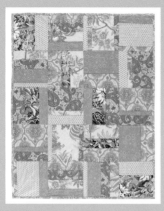

RENAISSANCE

32 x 40". Analogous.

PROVENCE

26-½ x 26-½". Complementary.

DOLL

13-½ x13-½". Complementary.
(Bonus)

CHOCOLATE-COVERED CHERRIES

17-½ x17-½". Neutrals. (Bonus)

ITALIAN ICE

17-½ x 28-½". Triadic.

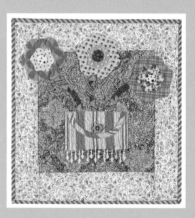

FUNKY FLORAL BOUQUET HANDBAG

16½ x 18½. Split-Complement.

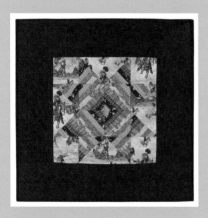

ROUND-UP STAR

38-½ x 38-½. Double-Complement.

BUNKHOUSE SCRAPS

15-½ x18-½. Round-Robin.

COTTAGE GARDEN

54-¼ x 54-¼". Create Your Own
Color Harmony (Bonus).

PART TWO

Making the Color Mastery Quilts

Analogous Color Wheel

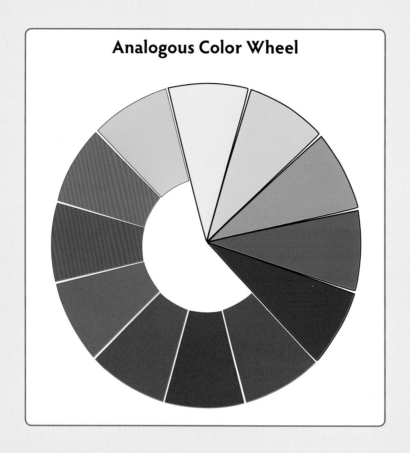

Complementary Color Wheel

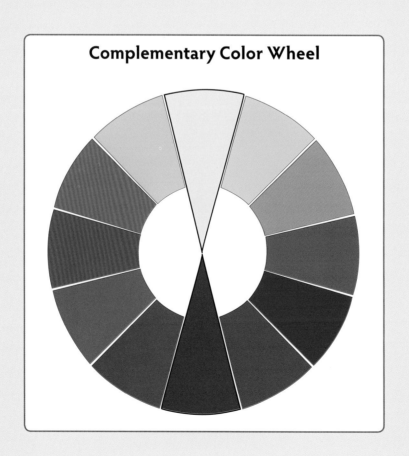

CHAPTER EIGHT

Basic Color Harmony Projects

It's time to put your newly acquired or more sharply honed color vision skills to the test. Let's apply them by using your fabric stash and the standard color harmonies to create a quilt. The basic harmonies have simple color relationships. They are the easiest to understand and are the springboard for the advanced harmonies in chapter 9. I recommend you master the concepts and practice of the basic harmonies presented in this chapter before moving forward with the advanced. Take a look at the two basic color harmonies and how they work in our quilts. They are:

So how do you decide on what analogous colors to use? Don't think in those terms. Think instead about what the inspiration for your quilt is and who it's for. Do the answers to those questions lead you to seek a high-contrast or low-contrast design? Do you know the main color you want to use? What other hues do you want to include? Are they analogous? If they are, great! If not, ask yourself if any of the analogous hues would work instead. You aren't limited to only analogous colors in a color scheme; rather, these are your main colors, but you can incorporate any other colors you like in smaller amounts.

Analogous

Analogous harmony uses two to five colors close together or adjacent to each other on the color wheel. Analogous harmony yields the lowest contrast of the six harmonies. Analogous colors are positioned next to each other on the wheel, so they are similar in relationship, and therefore have low contrast. Does that mean you can't use an Analogous color harmony in a high-contrast quilt design? Absolutely not. Since the hues alone don't provide the contrast, you can rely on the value and intensity of those colors to do so. Play up the contrasts in those elements and you'll have a higher-contrast color harmony even if you're using analogous colors.

Analogous colors don't have to be right next to each other on the wheel; they just need to be within about five spaces of each other in either a clockwise or counterclockwise direction. The farther apart two colors are, the more contrast they naturally have. Yellow and red are analogous colors but have lots of contrast since they're spaced farther apart on the wheel.

Complementary

Complementary harmony uses two colors positioned directly opposite each other on the color wheel. Complementary harmony is the highest contrast of the six color harmonies. Complementary color schemes are the easiest of all to use, as they provide instant contrast for pieced blocks and instantly achieve design definition in a quilt. If you're using a Complementary color harmony, you don't have to be as concerned about value and intensity as you would with the Analogous harmony. Even the rank beginner can use the Complementary harmony without fear of total failure.

Be aware, though, that complementary colors can sometimes be jarring, resulting in almost too much vibrancy. You could offer sunglasses to everyone who views the finished quilt—or you could plan ahead, when you realized the extreme impact of the palette in your color journal, and tone down the strength of complementary colors by using them in similar values and intensities.

Renaissance Quilt

Analogous Color Harmony

Renaissance is one of my favorite types of quilts: it delivers maximum impact for minimum effort (Matisse was the first to say this). The piecing in this quilt is super easy with no matching seams or triangles, but because the strips vary in width, the quilt looks complex. Another key to making this quilt successful is using busy fabrics: since the piecing is simple, you can use large-scale printed fabrics quite successfully here.

This quilt uses an Analogous color harmony of the green, blue, and violet families, which are close on the color wheel. Let's look at the fabrics and break down the harmony into the three main ingredients, as noted in Table 8.1.

Table 8.1 Analogous color harmony for Renaissance quilt

Hue	Value	Intensity
Green (paisley)	Light to Medium	Dull
Green (small scale print)	Light	Dull
Green (floral)	Light	Bright
Blue (floral)	Light, Medium, Dark	Bright
Blue (paisley)	Light to Medium	Bright
Violet (dots)	Medium	Dull

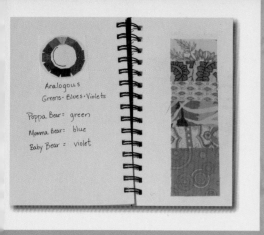

Notice the keys to the successful mix of ingredients in this harmony:

- Analogous color harmony

- One hue dominates, with the others playing supporting roles

- Variety in value, with enough contrast to add interest to a low-contrast color harmony

- Pleasing mix of brights and dulls, so the brights don't overwhelm the quilt

Here's where you get to choose:

Do you want to use these same colors, or substitute other analogous hues? Try some samples in your color journal before starting to cut and piece.

The best part about this design is that it couldn't be simpler. The quilt is made of 20—8" finished blocks in a 4x5 layout.

Materials

- 3 fat quarters (18 x 21") of green fabric
- 2 fat quarters (18 x 21") of blue fabric
- 1 fat quarter (18 x 21") of violet fabric
- 1-½ yards backing fabric
- 38 x 46" batting
- 1 fat quarter (18 x 21") of green fabric for binding

Finished Size:

32x40"

Cutting the Fabric

From each fat quarter, cut:

- 1—5-½ x 21" strip
- 1—3-½ x 21" strip
- 3—2-½ x 21" strips
- 1—1-½ x 21" strip

1. Combine the strips in random order into 8-½" wide strip sets. You are the designer here, so you get to decide what those random combinations are. One strip set may have only two strips (3-½+5-½") or four strips (2-½+2-½+2-½+2-½"). The key to a visually rich quilt here is getting as many different strip combinations as possible. Sample strip sets could be:

 3-½" + 5-½"
 1-½"+5-½"+2-½"
 2-½"+2-½"+3-½"+1-½"

 or any combination of strips that results in an 8-½" block. You will have some leftover strips. Save these to use in the Italian Ice scrap quilt later in Chapter 9.

2. Piece the strips together so you have 10—8-½" x 22" strip sets.

3. Cut the strip sets into 8-½" squares. I like using a square ruler for this, taping off the 8-½ x 8-½" area so I can visualize what my block will look like.

4. Layout your blocks in a 4 x 5 arrangement on your design wall or on the floor. Alternate the blocks between vertical and horizontal strip placement. Doing this gives the quilt more visual interest.

5. Piece together each row of four blocks.

6. Piece together the rows of blocks until the top is complete.

7. Layer, mark, baste, and quilt as desired. I machine-quilted a simple large cross-hatch design seen in many Italian Renaissance ironwork designs.

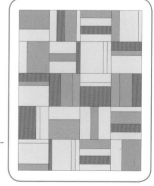

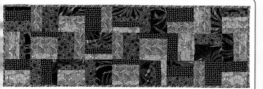

Color Harmony Option:

This fantastic fall table runner uses smaller 5-½" Renaissance blocks in a Triadic color scheme (p. 64) of orange, violet, and green. Since these colors are farther apart on the color wheel, they have greater contrast.

Provence Quilt

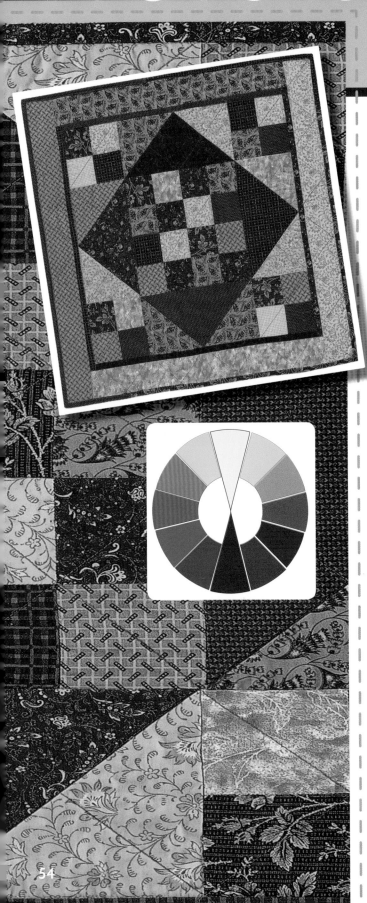

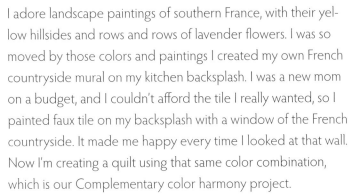

I adore landscape paintings of southern France, with their yellow hillsides and rows and rows of lavender flowers. I was so moved by those colors and paintings I created my own French countryside mural on my kitchen backsplash. I was a new mom on a budget, and I couldn't afford the tile I really wanted, so I painted faux tile on my backsplash with a window of the French countryside. It made me happy every time I looked at that wall. Now I'm creating a quilt using that same color combination, which is our Complementary color harmony project.

Remember, complementary colors are those directly opposite each other on the color wheel. The most commonly used complementary colors are red and green, as anyone who decorates during the winter holidays can tell you. Since we've already seen that color scheme plenty of times (maybe even too many), I intentionally chose a different color scheme for this quilt. In fact, I selected the complementary color combination most quilters are uncomfortable with: yellow and violet.

Why are so many people turned off by these colors? I believe it's because often we see electric shades of yellow so bright they overwhelm us, and violet is a color most quilters have trouble identifying. In the color wheel exercises in my color classes, the three violets (violet, red-violet, and blue-violet) give quilters the most trouble. My goal in designing this quilt is to demonstrate you can make a gorgeous quilt with yellow and violet; you just need to understand a few guidelines first.

How do you use yellow without it overwhelming your quilt? Use a darker value yellow or a dull version of the hue. Yellow is inherently bright and light; to counter those effects, go darker and duller on your value and intensity scales. The trick is balancing any naturally light, bright hue with a darker value and duller intensity. You'll be more successful with yellow.

This is probably the easiest color harmony to coordinate, as it really has only two colors. Table 8.2 breaks down the palette into the three main ingredients:

Table 8.2 Complementary color harmony for Provence quilt

Hue	Value	Intensity
Yellow	Medium to Dark	Dull
Violet	Dark	Dull

How can such a simple color palette with little variety in hue, value, or intensity be successful?

Here are the keys to the successful mix of elements in this quilt:

- Complementary color harmony
- Complementary hues provide all the contrast and do all the work for you; little to no value or intensity contrast is necessary
- Variety of fabrics; two hues but multiple fabrics in each
- Quilt design that needs contrast for definition

I cut swatches of these fabrics and pasted them in my color journal before I committed them to this quilt, and I recommend you do the same. Get into this creative habit and you'll be training your eye to discern hue, value, and intensity, and how they work together in your quilts.

I use a diverse array of fabrics in this quilt. Many are reproductions, but not all. The yellow fabric with pink and blue flowers is an actual French fabric given to me by a friend after her recent trip to Brussels. I've included prints, plaids, geometrics, marbled solids, and florals. The common element they all share is they fit into the Complementary color harmony.

ARTIST'S SECRET:
Use Diverse Fabric Styles. You don't need to limit yourself to one fabric design, such as all florals or plaids, in your quilts. You can arrange fabrics you never imaged together successfully when their common element is a color harmony.

(continued on next page)

[1] Elliott, Debbie, "Eric Carle's Wonderful World of Children's Books," All Things Considered, July 15, 2007, NPR, http://www.npr.org/templates/story/story.php?storyId=11889867.

Materials

- ¼ yard each of four violet fabrics
- ¼ yard each of four yellow fabrics
- 1 yard backing fabric
- 33" square of batting
- ⅓ yard of violet binding
- Crayola® Washable Marker " or pencil for marking

Finished Size:

26-½" square

Cutting the Fabric

From the violet fabrics, cut:

- 4–5-½ x 10-½" rectangles
- 16–3" squares
- 2–1 x 21-½" inner border strips
- 2–1 x 20-½" inner border strips

From the yellow fabrics, cut:

- 8–5-½" squares
- 16–3" squares
- 2–3 x 26-½" for outside border strips
- 2–3 x 21-½" for outside border strips

Piecing the Sixteen-Patch Block

1. Chain piece pairs of yellow and violet 3" squares. Make 8.

2. Chain piece yellow and violet pairs into four-patches. Make 4.

3. Piece four-patch units into two rows.

4. Piece the rows together to make the sixteen-patch inner block.

Piecing the Flying Geese Borders

1. Draw a line diagonally from corner to corner on the wrong side of each yellow 5-½" square.

2. Place a yellow square, right sides together, on one corner of a background rectangle. Sew on the drawn line. Press toward the outside edge of the rectangle. Carefully remove the inner triangle and discard.

3. Repeat placing a square on the opposite edge of the rectangle, being careful of the line placement and repeat step 2.

4. Repeat steps 2 and 3 with the remaining squares. Make 4 Flying Geese rectangles.

Color Harmony Option:

This was Kathy Brigman's first quilt, and she used red and green, the most familiar complementary color palette. Notice the variety of fabric styles that could otherwise be distracting are coordinated by a color harmony for a very attractive quilt.

" Crayola is a registered trademark of Binney & Smith, Inc.

Piecing the Four-Patch Corner Blocks

1. Chain piece remaining pairs of yellow and violet 3" squares. Make 8.

2. Chain piece yellow and violet pairs into four-patches.

Adding Borders and Sashing

1. Piece a corner block to each side of two of the Flying Geese borders. These will be your top and bottom rows.

2. Piece a Flying Geese border to the sides of the sixteen-patch block. This will be your middle row.

3. Piece together the rows into the quilt top as shown. The quilt center should measure 20-½" including seam allowance.

4. Add the violet inner borders to the sides of the quilt top.

5. Add the violet top and bottom inner borders.

6. Add the yellow outer borders to the sides of the quilt top.

7. Add the yellow top and bottom outer borders.

8. Layer, baste, mark, and quilt as desired.

9. Bind your quilt.

Doll Quilt

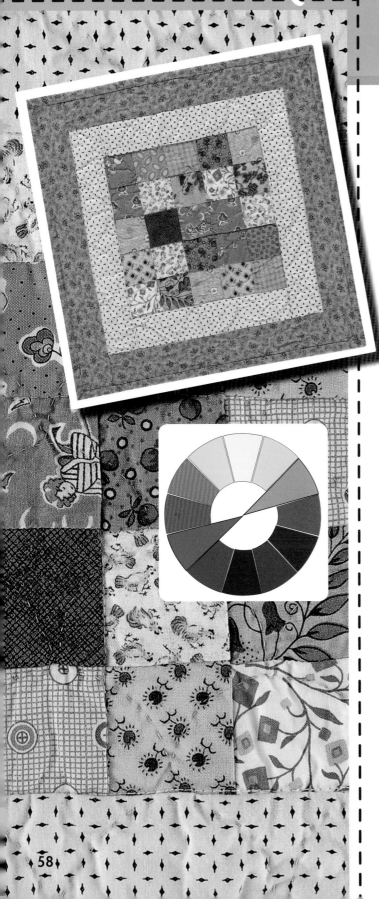

Complementary Color Harmony
BONUS PROJECT

Scrap quilts have a long, rich history. They represent the art of long-ago quilters making do with what they had on hand to work with. They make me think of pioneer women trekking across the country in covered wagons, recycling their clothing scraps to make a beloved quilt.

So why use a color harmony when making a scrap quilt? Using a color harmony is an outstanding way of pulling together lots of different fabrics and giving them a cohesive look; without a well-chosen color harmony palette, a quilt with lots of different fabrics runs the significant risk of being disharmonious. For the Doll quilt pictured here for your reference, I used a blue/orange complementary color scheme created from small pieces in my scrap bin. Feel free to use the Complementary color harmony of your choice. I've also done this in a pink/green combination that was darling.

Table 8.3 shows a breakdown of the color palette for this Doll quilt.

Table 8.3 Complementary color harmony palette for Doll quilt

Hue	Value	Intensity
Blue	Light, Medium, Dark	Bright, Medium Dull
Orange	Light, Medium, Dark	Bright, Medium Dull

This is one project for which I will admit I didn't use my color journal. I intentionally wanted to be surprised with the results. Be bold and just do it! After all, in this case, they're just scraps. The construction and cutting procedures for this quilt are quite simple. All squares and border strips are 2" wide.

Materials

• 12—assorted orange 2" squares
• 13—assorted blue 2" squares
• Fat eighth (9 x 22") white print for inner border
• ½ yard total orange prints for outer border strips and binding
• ⅔ yard backing fabric
• 20" square batting

Finished Size:
13-½" square

Cutting the Fabric

From the blue shirting prints, cut:
• 2—2 x 11" inner borders
• 2—2 x 8" inner borders

From the orange prints, cut:
• 2—2 x 14" outer borders
• 2—2 x 11" outer borders
• Enough 2-½" bias strips to total 74" of bias binding

1. Chain piece pairs of blue and orange squares. Make 10 pairs.

2. Sew two pairs together to make a row of four squares. Sew one additional square to the end to make a row of five squares. Repeat for all five rows.

3. Sew the five rows together to make the quilt center. It should measure 8" square, including seam allowances.

4. Sew a 2 x 8" blue shirting inner border strip to the top and bottom of the quilt.

5. Sew a 2 x 11" blue shirting inner border strip to the sides of the quilt.

6. Sew a 2 x 11" orange outer border strip to the top and bottom of the quilt.

7. Sew a 2 x 14" orange outer border strip to the sides.

8. Layer, baste, mark, and quilt as desired. I quilted a clamshell design all over the quilt to give it a vintage look.

9. Bind your quilt.

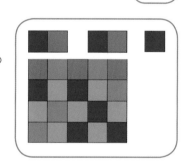

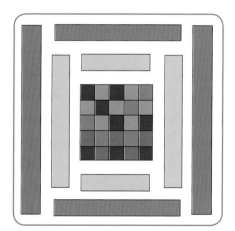

Chocolate-Covered Cherries Quilt

Using Neutrals for their Value in a Quilt
BONUS PROJECT

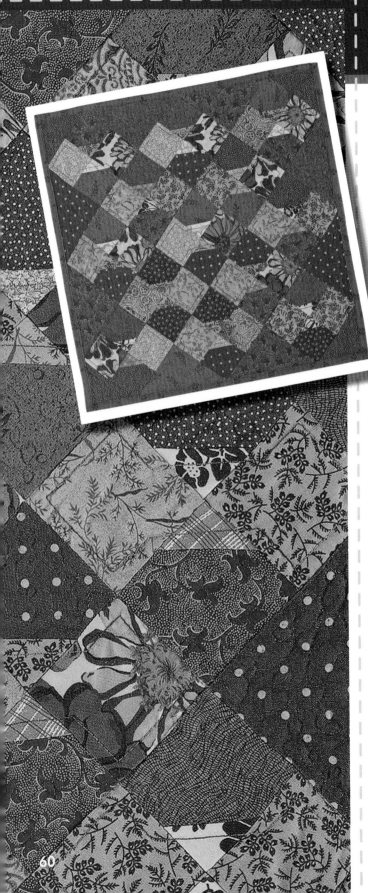

If neutrals don't affect the other colors in a quilt, why use them? Neutrals add richness and complexity to whatever colors you already have in your quilt. Using neutrals allows you to add other fabrics to your quilt without changing the color relationships among them. Neutrals are usually dull intensities, so they don't draw attraction to themselves, unless they offer a contrast in value to what's already in the quilt. Neutrals provide an easy way to add more fabric and more color to a quilt without upsetting the harmony you already have.

I've designed a bonus project that shows how you can use a neutral's value as an effective design element in a quilt. Chocolate-Covered Cherries is a Bow-Tie quilt that uses pink (light value red) in all intensities, with brown as the only other color in the quilt. It serves as the dark background for the cheerful pink bow-ties. The hues in this quilt appeal your emotions (chocolate and cherries—a classic color scheme), the values provide the contrast necessary for the Bow-Tie design, and the intensity of the pink balances the dull brown. It's a classic quilt design in a classic color combination.

While chocolate and cherries are a popular food combination, the colors aren't exactly a traditional color harmony. For this reason, it's probably a good idea to evaluate the color elements by preparing and pasting swatches in our color journals. In fact, every time you think about making a quilt, I urge you to perform this creative ritual. It's a good habit that's worth cultivating.

Table 8.4 Neutral color palette for Chocolate-Covered Cherries quilt

Hue	Value	Intensity
Red Bow Ties	Light	Dull, Medium, Bright
Brown Background	Dark	Medium, Dull

Materials

• ⅛ yard each of six pink fabrics
• ⅛ yard each of six brown fabrics
• ¼ yard of brown fabric for side and corner triangles
• ⅔ yard of backing fabric
• 23" square of batting
• Fat quarter (18 x 21") brown fabric for binding

Finished Size:

17-½" square

Cutting the Fabric

From the pink fabrics, cut:

• 26—2-½" squares
• 26—1-½" squares

From the brown fabric, cut:

• 26—2-½" squares
• 2—3-¾" squares, cut once diagonally from corner to corner for corner triangles

• 2—7" squares, cut twice diagonally from corner to corner for side triangles

Make the Bow Ties

1. Draw a line diagonally from corner to corner on the wrong side of each pink 1-½" square.

2. Place a 1-½" pink square, right sides together, on one corner of a brown 2-½" square. Sew on the drawn line. Press toward the outside edge of the rectangle. Carefully remove the inner triangle and discard. Make 26.

3. Place a 2-½" brown square right sides together with a pink 2-½" and stitch. Make 26.

4. Sew bow-tie units together as shown. Make 13.

5. Sew bow-tie units and side triangles in each row, join rows together and then add corner triangles..

6. if the rows are sewn together without the side triangles, you would have to set in the seams of the side triangles into the quilt top, as shown. The quilt top should measure 17-½" including seam allowances.

7. Layer, baste, mark, and quilt as desired.

8. Bind your quilt.

Sophisticated Color Harmony Projects

Advanced color harmonies have more complex color relationships than their basic counterparts, resulting in sophisticated color for even the most uncomplicated designs. Orchestrating an advanced color harmony requires more planning, but results in an exquisitely colorful presentation. It's worth devoting the time to understand and experiment with these harmonies; they can transform the color in your quilts from ordinary to extraordinary. Really. They work that well.

Let's take a look at the four sophisticated color harmonies and how they work in our quilts. They are:

Triadic

Triadic harmony is accomplished by combining three colors from the wheel, each positioned four spaces apart. Regardless of where you start, as long as you choose three colors positioned four spaces apart, the colors will work together. This is a medium contrast harmony that does a lot of the work for you. How is this possible? The three diverse colors provide visual complexity and have a balanced contrast. The colors aren't next to each other, nor are they directly opposite each other on the color wheel; you get a nice "middle ground" of contrast—not too little, not too much.

Split-Complement

Split-Complement harmony is achieved by using one color of your choosing, plus the two colors on either side of its complement. Huh? I know, it sounds confusing, but it's really not. Look at your color wheel. First, pick a color, let's say blue. Now find its complement—its complement is located directly opposite,

and blue's complement is orange. Now go one color clockwise and one color counterclockwise (that's the split part) from complement: those colors are yellow-orange and red-orange. So, the Split-Complement harmony here is blue, yellow-orange, and red-orange. Split-Complement harmonies are another medium- contrast color recipe that makes you look good every time. It's a cousin to the Complementary harmony, but with the contrast toned down a bit and the addition of a multi-faceted mix of colors.

Double-Complement

Double-Complement harmony is achieved by using two sets of complementary colors. For example, if you look at your color wheel, you'll see that red and green are complements and blue and orange are complements. Combining these four colors in a quilt would result in a quilt with Double-Complement harmony (red/green and blue/orange). Double-Complement harmony is a high-contrast color recipe, but because it has more colors, it has less contrast than a normal Complementary color harmony. Remember, the greater the variety of hues, the less importance and focus each one has.

Round-Robin

Round-Robin harmony is a variation of the Analogous color harmony. Round-Robin starts with one color and uses increasingly smaller amounts of each successive color around the wheel. This is a fun harmony that works well every time, as it incorporates the Three Bears rule of design. Just pick a place on the color wheel and go around the wheel, using less of each color as you move farther and farther away from

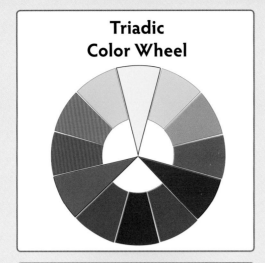

Triadic Color Wheel

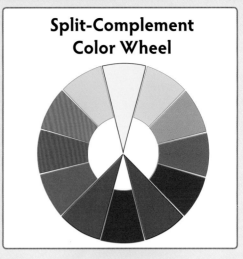

Split-Complement Color Wheel

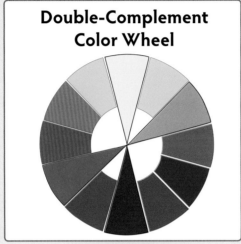

Double-Complement Color Wheel

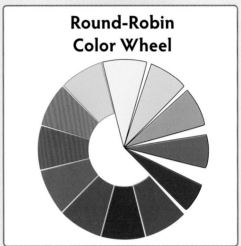

Round-Robin Color Wheel

your starting color. If you've never tried a Round-Robin quilt, I encourage you to do the one in this chapter. It's a fun one to try.

You've already done quick samples of these color harmonies on page 29. That gave you a taste of how these color harmonies come together. It's time for a larger serving of these wonderful recipes. Make an actual quilt, or just a pincushion, handbag, or whatever strikes your fancy with these harmonies. Put your understanding of color theory to work in the actual application of the color wheel harmony to a design. Each of the quilt projects I've included in this chapter are easy to construct, yet have a sophisticated look. They're like the mom in the Rice Krispies®[i] commercial, pretending to slave away all day in the kitchen, when really the treats

are a breeze to make. I've intentionally made the piecing simple to encourage you to focus on the color relationships in the quilt.

Devote a weekend to making a project in this chapter. Don't forget to test your color harmony in your color journal before you commit to a whole quilt (you'll be much happier with the end product—remember, if you're not happy with the swatches in your color journal, you probably won't be happy with the finished quilt), and watch your color preferences shine in one of these quilts. I've included a gamut of quilt styles here to suit lots of different tastes: a cowboy-themed Star quilt, a feminine Floral Appliqué quilt, and two quilts that take leftovers from the projects in Chapter 8 and transform them into something completely new.

[i] Rice Krispies is a registered trademark of the Kellogg Company.

Italian Ice Quilt

Triadic Color Harmony

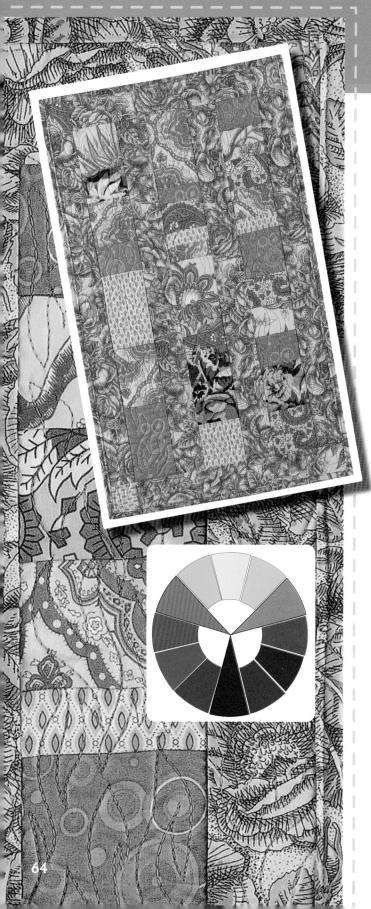

I avoid the word "perfect" when it comes to quilting. So many of my quilting students beat themselves up in their pursuit of mastering quilting skills and achieving perfection. All I'll say is that I believe the Triadic color harmony comes mighty close to being the ideal color harmony. Three colors chosen from evenly spaced positions around the color wheel means you get a variety of hues, with just the right amount of contrast. This color harmony instantly achieves a sophisticated balance of hues, making your quilt look like it was crafted by a true color master. I encourage you to not only try this project, but to use the Triadic color harmony often in your quilting. It's an outstanding color harmony that unites contrasting colors in a way few quilters would imagine on their own or by matching fabrics to their focus fabric.

A savvy use of color harmonies is to take leftover scraps from one project and transform them into a completely new look using a different color harmony. It's like taking leftovers from one meal and creating a whole new meal that your family raves about. Okay, maybe that's stretching the analogy a bit, but it really does work with fabric, perhaps better than it works with leftovers from the refrigerator.

Where do you begin? You can beneficially re-use leftovers by taking orphaned strip sets, half-square triangles, or other pieced "parts," and giving them a makeover for a completely different look. If I know the scraps came from an Analogous quilt, I'll use a different color harmony for the new quilt. Does that really work? Can you really take one color harmony and make it fit into another? Yes, you can, and that's exactly what this project demonstrates.

Recycling leftovers is a great way to flex your creative muscles, and sometimes I'll challenge myself to see how I can transform those pieced units into something new and completely unrecognizable from their original purpose.

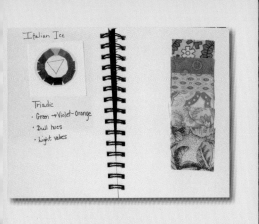

Notice the keys to successfully mixing the color elements in this palette:

• Triadic color harmony

• One hue dominates, with others playing supporting roles

• Color harmony provides all the contrast necessary, so a variety in value isn't necessary for this design

• Variety in intensity helps naturally light, bright colors blend better

Let's take our leftovers from the Renaissance quilt and use those to create a scrappy quilt. I had leftover strip sets that weren't big enough to be a block in Renaissance, so I kept them for use in this quilt. I'll even use them the same length—8-½"—but a shorter width—3-½". I call this quilt Italian Ice because not only do the colors remind me of the delectable display cases full of gelati and sorbets, but the Renaissance was born in Italy. This small quilt traces its design origins to the delicious, rich artistry of Italy.

The Renaissance quilt project in Chapter 8 used an Analogous color harmony of blue, green, and violet. We'll take the scraps from that Analogous quilt and use them in our new Triadic color harmony. Let's take a look at the process we'll use to repurpose leftovers from one color harmony project and fit them into a completely new color harmony quilt.

Our first color from Renaissance, blue, isn't four spaces away from either green or violet, so blue won't be one of the main colors in this harmony. Green is four spaces away from violet, so we can use those two as part of the triad. What color on our color wheel is four spaces away from both green and violet? It's orange.

I can hear your shrieks of horror. I know, orange is a challenging color for most quilters and many avoid it. But remember, you can use a bright hue in a color scheme without having that color overwhelm the others in the palette. Use a duller intensity, and in this case, possibly a lighter value, like perhaps a nice Georgia peach color. Think of the orange in this quilt as a peach gelato—that sounds better, doesn't it?

The orange fabric I chose wasn't a plain, solid orange; it also had green, both in duller intensities and lighter hues. Since the orange wasn't the only color in the fabric and it

wasn't a screamingly bright intensity, it plays well with the other hues in the triad.

Please don't feel like you need to stop what you're doing and go on a hunt for this exact fabric. Use whatever orange you have in your stash. I auditioned several orange fabrics that would have worked well for this project, and several of them they were orange-only fabrics. Remember, your quilt will look different from mine depending on what you have in your stash. It should look different, unless you've been digging in my stash. This is an exercise that stretches your color vision for your quilts, and you're using leftovers, for goodness' sake. Try something new and don't be afraid!

Table 9.1 provides a breakdown of the color palette for this Italian Ice quilt.

Table 9.1 Triadic color harmony for Italian Ice quilt

Hue	Value	Intensity
Green	Light	Medium
Violet	Medium	Dull
Orange	Light	Dull
Renaissance Scrap Units	Light to Medium	Bright, Medium, Dull

(continued on next page)

Try some samples in your color journal before starting to cut and piece.

Materials

- 9—leftover Renaissance pieced rectangles measuring 3-½ x 8-½" for inner strips
- 4—leftover 2-½" squares from Renaissance fabrics for corner squares
- ½ yard peach print for inner and outer borders
- 1 yard backing fabric
- 23 x 34" batting
- Fat quarter (18 x 21") green print for binding

Finished Size:

17-½ x 28-½"

Cutting the Fabric

From the peach print, cut:

- 4—2-½ x 24-½" border strips
- 2—2-½ x 13-½" border strips

Make the Quilt Top

1. Piece three 3-½ x 8-½" leftover Renaissance rectangle units together to make one long strip measuring 3-½ x 24-½". Repeat two times to make a total of three strips.

2. Sew a 2-½ x 24-½" border strip to each side of the pieced strips you made in step one.

3. Sew a 2-½" corner square to each end of the 2-½ x 13-½" strips. These border strips should now measure 2-½ x 17-½".

4. Sew the two pieced border strips to the top and bottom of the quilt top.

5. Layer, baste, mark, and quilt as desired.

6. Bind your quilt.

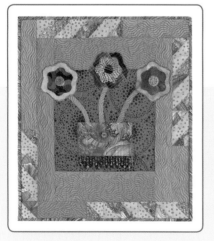

Color Harmony Option:

Here's a different quilt using the Triadic color harmony. Funky Floral Bouquet Handbag is the project for the next color harmony, Split-Complement, but I created another version in a Triadic color harmony for this quilt. Compare the Triadic version against the original Split-Complement version on page 67 and see what a difference using an alternate color harmony can make in the same quilt.

Funky Floral Bouquet Handbag Quilt

Split-Complement Color Harmony

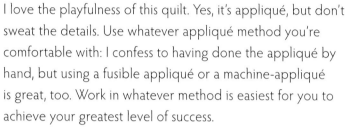

I love the playfulness of this quilt. Yes, it's appliqué, but don't sweat the details. Use whatever appliqué method you're comfortable with: I confess to having done the appliqué by hand, but using a fusible appliqué or a machine-appliqué is great, too. Work in whatever method is easiest for you to achieve your greatest level of success.

Remember the Split-Complement harmony uses three colors: one main color and the two colors on either side of its complement. Split-Complement harmonies are a well-balanced use of color; regardless of which hue you use as your starting color, its split complements will provide just the right amount of contrast. Depending on your particular preferences or those of the intended recipient of your quilt, you can adjust the level of contrast by tweaking the value and intensity of the three hues. You can also add other colors as accents; the color harmony references the main colors in your quilt, not the supporting cast of characters.

A Split-Complement color harmony is well-suited for an appliqué project because it offers several colors to choose from for a quilt design with many parts: stems, leaves, flowers, block borders, and more. You have lots of colors to choose from and they'll be harmonious because you used an advanced harmony Split-Complement recipe.

The red/green color palette is common in quilts; I wanted to go in another direction to embolden you to consider other options. I immediately thought of the blue/orange complement harmony: appliquéd flowers would look fantastic in bright oranges (with some similar reds and yellows thrown in), and a blue background could easily cool down the intensity of the flowers.

I used beads at the handbag bottom and a button as a mock closure; these notions are fun, completely optional touches that play up the whimsy of the finished quilt. This is a color exercise, after all, and I happened to have them on hand. If you want to add that stuff, fine. Otherwise, skip it and don't feel guilty.

Table 9.2 provides a breakdown of the color elements in the Funky Floral Bouquet Handbag quilt.

Table 9.2 Split-Complement color harmony for Funky Floral Bouquet Handbag quilt

Hue	Value	Intensity
Blue Background	Medium	Medium, bright
White and Blue Border	Light	Dull
Red-Orange Handbag and Flowers	Light	Medium, Dull
Yellow-Orange Flowers	Light to Medium	Bright, Medium

Again, try the fabric swatches in your color journal before starting to cut and piece. Use the same hues as I did, or be a pioneer and use other hues in a Split-Complement color harmony.

Materials

- 3—5" scraps in yellow-orange and red-orange prints for flower appliqué bottom
- 3—3" scraps in yellow-orange and red-orange prints for flower appliqué middle
- 2—3" scraps of blue and one 3" scrap of red-orange fabric for flower appliqué top
- 1 fat eighth (9 x 22" rectangle) of green print for stems
- 1 fat eighth (9 x 22" rectangle) of red-orange stripe for handbag
- 1 fat quarter (18 x 22" rectangle) of blue print for background
- ¼ yard of blue and white print for border
- ⅔ yard of backing fabric
- 23 x 25" rectangle of batting
- One fat quarter (18 x 21" rectangle) of blue stripe for bias binding
- 7" strip of beaded trim
- Button
- Flower templates A and B
- Yo-yo template C
- Fusible web (optional)

Finished Size:
16-½ x 18-½"

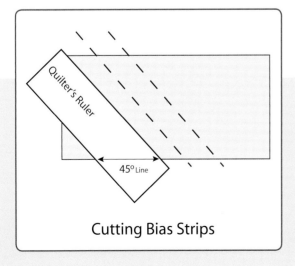

Cutting Bias Strips

Tips for Cutting Bias Stems

Bias strips are cut on the 45-degree diagonal grain of the fabric, which has the most stretch and creates beautiful curves for appliqué, bias stems, and bias binding. Cut the strips from a square or rectangle at a 45-degree angle from the left edge of the fabric. Align the 45-degree line on your 6 x 24" ruler along the bottom edge of the fabric to position yourself correctly for your first cut. Then cut strips the width you need parallel to that edge.

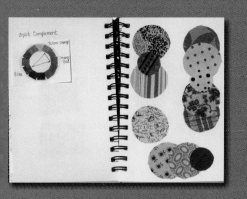

Cutting the Fabric

From the blue background print, cut:

- 1—6-½ x 12-½" rectangle
- 1—2-½ x 12-½" rectangle
- 2—3-¼ x 4-½" rectangles

From the red-orange stripe for the handbag and handle, cut:

- 1—1-¼ x 17" bias strip
- 1—7 x 4-½" rectangle

From the green print for the stems, cut:

- 3—1-¼ x 7" bias strips

From the red-orange and yellow-orange fabrics for the flowers, cut:

- 3 of templates A and B

From the blue and red-orange for the yo-yo centers, cut:

- 3 circles drawn from Template C or the top of a large spool of thread

From the blue and white border print, cut:

- 2—2-½ x 18-½" border strips
- 2—3-½ x 14-½" border strips

From the beading strip, cut:

- 1—7" strip

From the blue striped print for bias binding, cut:

- Enough 2-½" bias strips to total 80" of bias binding

Make the Handbag

1. Make the handbag handle by folding both raw edges of the 1-¼ x 17" bias strip toward the middle, wrong sides together, overlapping the edges. Machine-baste the strip, stopping about every 3" to fold the next section of edges toward the middle.

2. Machine-appliqué the orange bias strip to the orange stripe 7-½ x 4-½" handbag piece, referring to the photo of the quilt for placement. Remove the machine basting.

3. Place the beaded trim strip, right side down, on the right side of the bottom of the handbag, with the beads extended onto the handbag. Sew a scant ¼" from the edge of the handbag using a zipper foot. Your beaded bag is now ready for its flowers!

Make the Background

1. Sew a blue 3-¼ x 4-½" rectangle to each side of the handbag.

2. Create three flower stems by using the same machine-basting method you used for the handbag handle.

3. Machine-appliqué the three green bias strips to the blue 12-½ x 6-½" piece, referring to the quilt photo for placement. I created a funky feel by curving the stems in random directions, adding visual interest.

4. Sew the blue piece with the green stems to the top of the orange handbag piece.

5. Sew the blue 12-½ x 2-½" strip to the bottom of the orange handbag.

6. I added the borders before I added the flowers, as I wanted to extend the flowers into the border, giving the quilt a coloring-outside-the-lines feel. To do that, sew the 14-½ x 3-½" borders to the top and bottom of the blue background.

(continued on next page)

7. Sew the 2-½ x 18-½" strips to the right and left sides of the blue background. Now you get to add those flowers!

Adding the Flowers

I use Gwen Marston's methods for making the yo-yo centers and hand-appliquéing the flowers. I offer only basic explanations here; for more detailed instructions, I recommend Gwen's books listed in the bibliography.

1. Appliqué three flowers on top of the three stems. I extended my flowers into the border for an even funkier feel, but you are free to take a more conservative approach and remain within the lines.

To machine-appliqué, fuse the flowers into place and use a small zig-zag or buttonhole stitch to secure them.

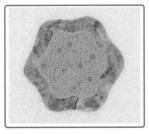

To hand-appliqué, loosely baste Appliqué B onto Appliqué A. Appliqué these first by turning the seam allowance under with your needle as you stitch. Hide the knot under the appliqué, and insert the needle at the turned-under edge. Take a stitch slightly forward and under the lip of the appliqué. Clip inside curves when you are about an inch or two away. Do the same with Appliqué A to attach it to the background.

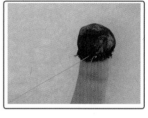

2. To make the yo-yo centers, hand-baste around the edge of the circle. Put your pinky finger into the center of the yo-yo and draw the thread up around it. Tie a knot to secure the gathering. Use your fingers to shape the yo-yo into a circle. You may find it helpful to use your needle to shape stubborn edges into a round shape. Appliqué these onto the center of the flowers.

3. Layer, mark, baste, and quilt. I created a quilted bouquet by adding quilted flowers between and around the appliquéd flowers. I also quilted right up to the appliquéd flowers with a filler design to make the flowers "pop" up. Again, you can choose your preferred level of funky-ness by quilting according to your liking instead of mine.

4. Bind the quilt using the 2-½" bias binding strips.

5. If desired, sew a funky button above the handbag handle and you're done!

Artistic License: I created another version of this quilt in a Triadic color harmony for a guild challenge. I also added a offbeat half-square triangle border. I've included a picture of that quilt on page 66.

Tips for Fusible Appliqué

To use fusible machine appliqué, trace the templates onto the paper side of the fusible web. Rough-cut each appliqué shape from the fusible web, and press them onto the wrong side of your fabric. Let the fabric cool. Cut out fabric shapes along the drawn line. Score the paper backing with a pin and peel off.

Round-Up Star Quilt

Double-Complement Color Harmony

I've always been fascinated with the striking Lone Star quilt: a beautiful design with impressive piecing. I was inspired to create my own design: a star with a complex, folk-art look, with simple construction techniques. It would look great in a boy's room, a man's game room, or in any room in Texas!

My inspiration for the color palette came from a magazine photo of a cowboy-themed boy's bedroom. On the wall, above the bed, was an old cowboy sign with dusty (dull intensity) prairie colors of red, green, blue, orange, and violet. I took the colors right out of that photo, and did an inspiring test page in my color journal. Notice the violet doesn't really fit into the Double-Complement color harmony, but who says we're limited to only those colors? The harmony is there and the violet, in a dull shade, fits right in.

Table 9.3 breaks down the color palette for this lovely Round-Up Star quilt into its the three main color elements.

Table 9.3 Double-Complement color harmony for Round-Up Star quilt

Hue	Value	Intensity
Blue Border	Dark	Dull
Tan Star Background (orange is its source hue)	Medium	Dull
Red	Medium	Dull
Green	Medium	Dull
Blue	Medium	Dull
Tan (star)	Medium	Dull
Violet	Light	Dull

71

Audition fabric swatches in your color journal before starting to cut and piece.

Materials

- 1-1/3 yards of blue for border and binding
- 2/3 yard of tan cowboy print for background (allow extra to cut from directional print, if needed)
- ¼ yard each of red, blue, tan, green, and violet fabrics for star
- 2-½ yards of backing fabric
- 45" square of batting
- Crayola Washable Marker or pencil for marking

Finished Size:

38-½" square

Cutting the Fabric

From the blue border fabric, cut:

- 4—2-½ x 42" binding strips
- 2—8-½ x 38-½" border strips
- 2—8-½ x 22-½" border strips

From the tan background print fabric, cut:

- 4—6" squares
- 4—6 x 11-½" rectangles. If you are using a directional print, you may need to cut the top and bottom rectangles from the length of the fabric.

From each of the star fabrics (red, green, tan, blue, and violet), cut:

- 4—1-½ x 42" strips

Piecing the Striped Star Fabric Set:

1. Arrange the strips in order so value contrast is spread throughout the set, rather than concentrated in just one area. You will likely need to change the arrangement a few times, but remember—we're playing here. Have fun!

2. Strip-piece the 1-½" strips to make one large new piece of fabric, offsetting the strips 1 to 1-½" so they make a graduated, stair-step edge. Press.

3. Using a 6 x 24" ruler, align the 45-degree line along the bottom edge of the strip set. Cut along the 45-degree angle into 6" bias strips across the fabric.

4. Cut twelve 6" squares from the strips.

Piecing the Star Center

1. Select four striped squares and place them in a four-patch arrangement for the center part of the star. Audition the squares for the interplay of hues and values in the stripes. Continue to try different squares until a particular one strikes your fancy. I arranged mine in a funky Barn-Raising design.

2. Piece the squares into two-by-two rows, then into a four-patch block. Gently press. Quilt center should measure 11-½", including seam allowances.

Color Harmony Option:

Pat Froelich made a second version of the same quilt, using the same colors but having yellow-orange borders and a violet background, all in bright intensities. What a different intensity makes!

Here are the keys to successfully mixing the color elements in this quilt:

- Double-Complement color harmony
- One hue dominates, while the others play supporting roles
- High contrast between the star, background, and border, both in hue and in value, making the star the focus of the quilt
- Dull hues that evoke a dusty, rustic cowboy theme, making this quilt feel as though it's just been lifted from an old bunkhouse

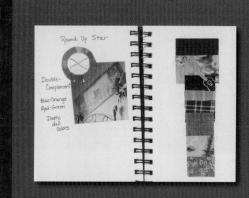

Piecing the Star Points

1. On eight pieced squares, draw a diagonal line, from corner to corner, on the back.

2. Place a striped square on one corner of a background rectangle, right sides together. Sew along the drawn diagonal line. Gently press the triangle toward the outside of the tan rectangle. Carefully trim away the inside triangle. This won't be used again. Do not cut away the tan background print. It serves as a foundation for the bias strips. Save the striped scrap for the Bunkhouse Scraps quilt in Chapter 7.

3. Add a second striped square to the opposite corner of the rectangle and repeat Step 2 to make a total of four star foundation squares.

Assembling the Round-Up Star Units and Adding Borders

1. Sew the units into rows.

2. Sew the rows together.

3. Sew the 8-½ x 22-½" border strips onto the left and right sides.

4. Sew the 8-½ x 38-½" border strips onto the top and bottom.

5. Layer, baste, mark, and quilt as desired.

6. Bind the quilt.

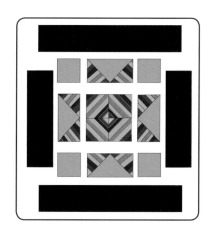

73

Bunkhouse Scraps Quilt

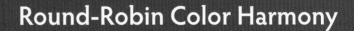

Round-Robin Color Harmony

Here's another project that begins with leftover blocks, this time from the Round-Up Star quilt, and gives them a completely new look. Recycling leftover scraps is a great great way to flex your creative muscles and reduce the volume of it's-too-pretty-to-just-throw-away pieces that flood your stash. Challenge yourself to see how you can transform those pieced units.

We'll use our leftovers from the Round-Up Star quilt to create a scrappy quilt. I had some leftover strip sets that I cut into squares: some bias squares and some straight, depending on how much I had left of each strip set.

What do you say we try a new color scheme? We used a Double-Complement color harmony in the Round-Up Star quilt, so let's use something completely different this time. The pieced squares are so small and contain so many different fabrics, they aren't going to play a big factor in the color harmony. They contribute to the scrappy look, but won't affect the color relationships because of the small amounts of fabric in each square.

Since we used a harmony from the Double-Complement family in the Round-Up Star quilt, let's try one from the Analogous family this time. Round-Robin is an advanced version of the Analogous color harmony. It contains analogous hues, starting with the greatest amount in the first hue, and decreasing amounts in the adjacent hues on the color wheel.

Table 9.4 provides a breakdown of the color palette for this scrappy Bunkhouse Scraps quilt.

Table 9.4 Round-Robin color harmony for Bunkhouse Scraps quilt

Hue	Value	Intensity
Red border	Medium	Bright
Red-violet sashing	Light	Dull
Violet binding	Dark	Dull
Round-Up Star scrap units	Light to Medium	Light, Medium, Dark

Notice the keys to successfully mixing the ingredients in this recipe:
- Round-Robin color harmony
- One hue dominates, while the others play supporting roles (a Round-Robin harmony guarantees this)
- Variety in value
- Greatest intensity in the bright red border, with other dull fabrics that calm down the bright red

Again, you can choose to use the same hues as I did, or follow your own creative whim by using other hues in a Round-Robin color harmony. Try some samples in your color journal before starting to cut and piece your quilt.

The measurements I give here are guidelines only, and yours may vary since we're using scraps. Cut your border, sashing, and binding to the lengths necessary to accommodate your scrappy squares.

Materials
- Leftover Round-Up Star strip sets or enough pieced scraps to cut twelve 2-½" squares
- ¼ yard of red-violet fabric for sashing
- ¼ yard of bright red fabric for border
- ⅔ yard of backing
- 23" square of batting
- One fat quarter (18 x 21" rectangle) of violet fabric for binding

Finished Size:
15-½ x 18-½"

Cutting the Fabric
From the leftover strip sets from the Round-Up Star quilt or other scraps, cut:
- 12—2-½" squares

From the red-violet sashing fabric, cut:
- 5—1-½" strips of fabric, widthwise

From the red border fabric, cut:
- 2—3 x15-½" strips for borders
- 2—3 x13-½" strips for borders

Make the Quilt Top
1. Place the twelve scrappy squares on top of the sashing strip, right sides together. Place the squares close together but don't overlap the edges. Stitch. Rotary-cut apart the units when you finish piecing.

2. Place four scrappy squares on top of a sashing strip and repeat Step 1. These will be your squares for the end of the row, which is why they need two sashing strips.

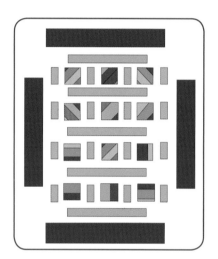

3. Piece three squares to make one row. Repeat this step for three additional rows to make four rows.

4. Measure the length of your rows. Cut five sashing strips to length for the horizontal sashing. Add the horizontal sashing for each row.

5. Piece rows together to make the top of the quilt. The inner section of the quilt should measure 10-½ x13-½".

6. Add the 3 x13-½" borders to the sides of the quilt.

7. Add the 3 x15-½" borders to the top and bottom of the quilt.

8. Layer, baste, mark, and quilt as desired. I marked an all-over fan design and hand-quilted it to give the quilt a vintage look.

9. Bind your quilt.

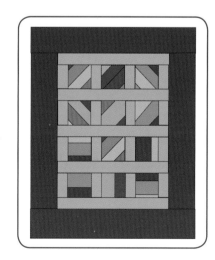

CHAPTER TEN
Creating Your Own Color Harmony

What if the colors you want to use don't fit into a traditional color harmony? Are you obligated to use only colors that fit into a traditional color harmony? Absolutely not. You can create your own color palette based on your newfound or reinforced knowledge of color relationships. If your eye tells you the colors look good together—as you've tested them in your color journal—then you go right ahead and use them to your heart's delight. I don't always follow the traditional color harmonies or adhere stringently to them, but they're a good starting point for achieving guaranteed good results with very little risk. As we go through this chapter together, I'll be using a quilt I designed and created, pictured on page 77, as an example of how you can create your own color harmony. I explain the thought process I followed and the creative decisions involved in developing my own color harmony.

Where do you begin? How do you create an entirely new color harmony not based on any previous one we've used? You begin by asking yourself a series of key questions; the answers to which will help you to design and define your color harmony.

Inspiration

What is the inspiration for your quilt? The answer to this one question determines the focus of the quilt and your starting point. If your inspiration for the quilt is a magazine photo with colors you adore, you know that color will be your focus.

What if you've seen a fantastic quilt pattern and can't wait to try it for yourself? If so, then the design of the quilt will be your focus, and your color harmony will reflect the hues, values, and intensities needed to define the design. What if you're an art quilter and you want to create a new piece? If you're creating a pictorial quilt, you'll likely be focusing on value to create realistic shapes that people can easily recognize. If you want to make a Civil War reproduction quilt or a quilt based on 1930s fabrics, you know your color harmony will support the hues, values, and intensities needed to create those effects. Have you found a fabric you absolutely must use in a quilt?

My inspiration was a quilt a friend made using floral fabrics in a Drunkard's Path design. I loved the garden feeling of the quilt, with its vibrant colors and circular design.

Design

Are you making a quilt from a pattern, reproducing an antique quilt you saw at a flea market, interpreting a painting from an artistic master, or a using a wonderful mosaic tile pattern? Identify your design source and you'll be on your way to making the creative choices necessary to create your own color harmony.

While my friend's quilt was a Drunkard's Path, I created my own design based on an herb garden I had in my backyard. It had short white fencing around four beds that overflowed with lavender, rosemary, and sage. I created my own version of

that garden by interpreting it as a circle appliquéd onto a square, surrounded on two sides by a strip of striped fabric. The circles were my flowers and herbs, the background was the soil, and the striped fabric represented my fencing.

Contrast

How much contrast does your quilt design require? In what parts of the quilt is contrast necessary? Do all areas of the quilt need the same amount and type of contrast? What kind of contrast is needed? Will it be hue, value, intensity, or temperature? The area that will be the focus of your quilt will require the greatest contrast.

I wanted the most contrast to be between the striped fencing and my floral fabrics. The difference in style between the florals and stripes provided much of the contrast already, and I reinforced the contrast with a difference in value. Each strip of fencing contrasts to the floral background fabric.

I also needed contrast between the floral circles and floral background fabrics, and because the fabrics were all florals, the difference would need to be strong. I used both hue and value contrasts, according to the fabrics I had in my stash.

Hue, Value, or Intensity Contrast?

Do you know what colors or fabrics you'll be using? Much of this decision hinges upon your inspiration. If you are basing your quilt on a photo or room colors, you'll probably have colors in mind before you even look to see what fabrics you have on hand. Maybe you've seen another quilt with similar colors and you want to start there. Will you want any neutrals? Would white, black, brown or gray add to the visual appeal of your quilt?

How about values? Your answers to the contrast questions will help you to determine what values your quilt needs and where it needs them.

Is intensity important? Would working a small bit of intensity contrast into your color harmony give your quilt the added richness you desire?

For my quilt, I knew I wanted to use the hues I saw in my garden. It definitely needed reds and greens, as well as some yellows, oranges, and violets. Also, I had some floral fabrics I was excited to use, especially some beautiful blues, even though you don't see many blues in my garden. Almost every hue on the color wheel is included in this quilt. So how does it manage to be harmonious, with so many hues? Red and green dominate; not intentionally, that's just the way my quilt worked out. I also decided not to use neutrals, so my quilt has an Impressionists feel.

I have light, medium, and dark values throughout, with my choices dominated by contrast among the circle, background, and fencing for each block.

As far as intensity, I tried not to have too many brights, because this was already a busy quilt. It had lots going on in it, and I felt that too much intensity would overwhelm the lovely garden feel. You'll see mostly mediums here.

Role of Your Color Journal

Testing your color harmony is even more crucial when you're not sticking to a traditional one. It's in your color journal that you realize the impact and effectiveness of your creative decisions before you commit them to a quilt. That's why I encourage you to put your inspirational photo, design source, and a mock-up block in your color journal to test your hue, value, and intensity choices, and a color wheel in miniature to map the hue relationships.

Cottage Garden Quilt

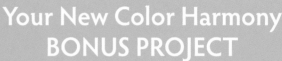

Your New Color Harmony
BONUS PROJECT

What would my new color harmony look like? Well, I can't tell you what your new color harmony would look like, but I can tell you what mine looked like. It's in Table 10.1.

Table 10.1
Custom color harmony for Cottage Garden quilt

Hue	Value	Intensity
Garden hues—all on the wheel	Light, Medium, and Dark for contrast between appliqué circle and background.	Medium and Dull—few Brights
Garden hues—all on the wheel	Light, Medium, and Dark for contrast between background and striped fencing.	Medium and Dull—few Brights

Cottage Garden

Keys to the Cottage Garden color harmony:

- Garden hues, primarily reds and greens
- Contrast in fabric styles—florals vs. stripes
- Value and intensity contrast
- Variety in scale, with larger floral prints on appliqués and smaller-scale florals in background

Materials

- 3—18 x 22" (fat quarter) pieces of assorted floral fabrics (side triangles)
- 27—8" squares of floral fabrics (corner triangles, blocks)
- 25—4" squares (appliqué)
- 16—⅛ yard pieces of assorted striped fabrics
- ⅔ yard green stripe (binding)
- 3-½ yards backing
- 61" square of batting

Finished Size:

54-¼" square

Cutting the Fabric

From the floral fabric, cut:

- 3—14-¾" squares, cut twice diagonally in an X to make 12 side triangles
- 2—7-⅝" squares, cut once diagonally to make four corner triangles
- 25—8" blocks
- 25—Circles cut from Template D (or cut 4" circles)

From the striped fabric, cut:

- 25—2-½ x 10" rectangles
- 25—2-½ x 8" rectangles

From the green striped fabric, cut:

- 1—24" square, cutting enough 2-¼" bias strips to make 230" of binding

Make the Quilt

1. Appliqué a circle (template D) , either by hand or machine (refer to chapter 9 for appliqué instructions) onto the middle of each 8" square.

2. Sew a 2-½ x 8" strip of striped fabric to the bottom of each square.

3. Sew a 2-½ x10" strip of striped fabric to the left side of the square. The block should measure 10" square, including the seam allowances.

4. Lay out the blocks and side triangles in seven diagonal rows. Sew each row together. Then join the rows. Add the corner triangles. The quilt top should measure 54-¼" square, including the seam allowances.

5. Layer, baste, mark, and quilt as desired.

6. Bind your quilt.

Table 10.2 lists the questions you should ask yourself and a place to record your answers when you're ready to create your own color harmony. While you might find yourself asking more questions, I suggest you start with these as the basis of your creative decision making process.

Table 10.2 Creating your own color harmony

Think About	What Your Heart/Eye Tells You
Inspiration	
Quilt Design	
How much contrast (a little, a lot, somewhere in between)?	
What kind of contrast (hue, value, intensity, temperature, fabric style)?	
Where to provide greatest contrast?	
Hues	
Values	
Intensities	

KNOW THIS:
You can build your own color harmony based on your knowledge of the three elements of color, contrast, and harmony.

THINK ABOUT THIS:
Do you have an idea for a quilt that uses colors that don't fit into a traditional quilt harmony?

DO THIS:
Fill in the *Creating Your Own Color Harmony* table to analyze your quilt design's color needs and relationships.

Frequently Asked Questions About Color

The quilters in my color classes ask lots of astute questions about color. Their questions demonstrate to me the frustrations they've experienced and the struggles they undergo in their attempts to commit to various color options in their quilts. I'm including the most frequently asked questions because I think the answers to my classroom students' questions can benefit you, too.

What about primary, secondary, and tertiary colors? Don't we need to know about them?

Primary, secondary, and tertiary are color terms that have to do with mixing colors. These are terms used most often by painters, who can mix paint colors together to create new colors. Since quilters don't mix two or more fabrics to create a new fabric, these terms really aren't relevant for most quilters. But just so you know, primary colors are the pure colors: yellow, red, and blue. Secondary colors are two primaries mixed together, resulting in orange, violet, or green. Tertiary colors are a secondary color mixed with a primary, resulting in the colors with two names, such as yellow-orange, orange-red, red-violet, blue-violet, blue-green, and yellow-green.

What are tint, tone, and shade? I often see these terms used in quilting magazines and don't really understand them.

Tint, tone, and shade refer to changes in both a color's value and intensity. In each case, the colors become duller and either lighter or darker by mixing white, black, or gray into the original hue. Since we quilters and fiber artists aren't mixing colors, these terms aren't particularly relevant for most of us. Tint, tone, and shade ultimately refer to a color's value and intensity, so I use those terms instead. I think using the terms that refer to the medium we quilters use clarifies other quilters' understanding of color.

Technically, a tint is a pure hue mixed with white to make it lighter and duller. Tone is a pure hue mixed with gray to make it darker and duller. Shade is a pure hue mixed with black to make it darker and duller.

What does saturation mean? I hear lots of quilting teachers calling colors "fully saturated."

Saturation is another name for intensity. I don't use that term because I think it's easily confused with value. Intensity is a better description, as it automatically paints a picture in your mind of a bright color.

Should I select my color harmony based on the number of colors I'm using in my quilt?

Selecting a color harmony based on a predetermined number of colors isn't an intuitive way of making a quilt, and it limits you unnecessarily. I think you can use as many colors as you want in a quilt, no matter what color harmony you're using; it's only the main

colors that you plug into a color harmony to get the result. Think of your main colors as the stars of the play you're directing and the remaining colors as the supporting cast.

A better way of choosing a color harmony is to determine how much contrast your quilt design needs: high, medium, or low. Once you've made this determination, you can select your color harmony based on that decision. Refer to the Color Harmony by Contrast chart on page 44 and in the Appendix. Then select the colors to use in that harmony based on the colors you enjoy working with: if your favorite color is blue, figure out how to make it work in every color harmony, and you'll have an infinite range of color relationships at your fingertips.

I also do other kinds of fiber art. Can I use these principles for knitting or rug hooking as well?

The principles covered in this book work with all types of fiber, whether you work in cross-stitch, crochet, weaving, knitting, rug hooking, embroidery, needlepoint . . . the list is endless. Since it's all about the interaction of colors in a fiber project, you can do the exercises with any type of fiber. Create color wheels using embroidery floss or hand-dyed wool. Fill in the Custom Color Harmony table on page 29 using yarns for your knitting. Whatever type of fiber art you do, these color exercises can help you to improve your color selections.

Do I still need to use a color harmony if I'm making a scrap quilt?

If you want a primitive look to your scrap quilt, use intuition. That's how our foremothers did it, and we've all seen fabulous antique quilts. The International Quilt Study Center has a wonderful online library of images of antique quilts (go to www.quiltstudy.org) where you can view some fine examples of how creative decisions hinged on value.

If you'd like a more sophisticated, artistic look to your quilt, I suggest you use a color harmony. I enjoy the quilts I made before I understood the color wheel, but see a great difference in the visual appeal of my early quilts and my greater understanding of the sophisticated use of color.

Can I plan my color harmony using the computer?

I don't recommend using the computer for selecting colors in fabrics. The colors you see on your computer monitor rarely translate well to fabric. You simply learn more by using the actual fabric. And there is just something about doing a color mock-up with fabric that is simply more effective than doing it on the computer. Even the best monitor can't deliver the subtle variety in hue, value, and intensity of the actual fabric. And there's the whole matter of the camera that was used to capture the image you're viewing on your monitor, the light in which the image was captured, and the angle from which the image was captured. Using your computer to plan your color harmony incorporates too

many variables that are out of your control. Your color journal is the best way to audition fabric choices, and I've taken great pains to recommend a process that's easy, quick, and painless.

What if I used a color harmony and I don't like the result in my quilt?

Don't abandon the process altogether. Do you know how many works artists reject for every one you see hanging on a gallery wall? We are our own toughest critics, and it may well be the quilt will grow on you over time. If not, look at it as a learning experience, and analyze exactly what it is about the color palette you don't like in the finished quilt, particularly if you liked the color palette when you did a mock-up of it in your color journal. Is it the hue, value, intensity, or temperature you dislike in the finished quilt? Write your answers on the mock-up page for that project in your color journal so you can remember it next time you get the urge to use those same colors.

What colors don't go together?

I've heard this question many times from quilters who seek absolute rules about color. Unfortunately, it's not that simple. The question to ask yourself is, "What color relationships don't work?" The color relationships I've seen and thought needed the most help are those in quilts that have too much contrast in all areas; the result was a jarring

mess, even if the individual colors were pretty and the design is wonderful. On the other hand, quilts with not enough contrast suffer from disappearing design syndrome; all the work of the maker is lost in a sea of sameness.

Does one fabric dominate the others, so you don't notice all the other gorgeous fabrics in the quilt? Does the quilt have all brights and no dulls (or vice versa), so the quilt is one-dimensional?

Realize that if you are trying to achieve a certain historic look, such as a Civil War reproduction or 1930s quilt, you may be forced to break these guidelines. And remember, as long as you understand color relationships, you can feel free to break the rules to achieve the look you want.

What's wrong with using the colors in the focus fabric as a guide for the other fabrics in the quilt?

There's nothing wrong with this approach, but you can do better. When you stick to the colors in one fabric, you are handing over your color choices to someone else, namely the fabric designer. While you might love the colors in one fabric, you may not be as thrilled when you see it one a large scale in an entire quilt. Also, most quilt shops don't have all of any one fabric line, so even if a designer or manufacturer has a fabulous selection, it's unlikely your local shop can carry it all. Develop your own color vision by using what you've learned about color relationships and you can transcend what you see in one particular fabric.

Imagine an exotic getaway, complete with palm trees, a gorgeous beach, four-star accommodations, and a personal chef. That's this quilting teacher's dream retreat.

Then there's the real world, filled with work schedules, family obligations, personal responsibilities, and the harsh reality that few of us can afford our own private island or the luxury of a week-long vacation to such a setting.

I've established an affordable middle ground between my dream and life's realities and I invite you to share it with me and our fellow quilters. I'd love to see you in one of my upcoming classes on Color Mastery, but I understand not everyone is able to escape for these one- and two-day lessons, so I've provided the schedule and itinerary I use for my annual Color Mastery retreat. Offered in my home studio, the retreat is a two-day, intensive learning experience, albeit without the palm trees and beach. With a little of my know-how and your imagination, there's no reason you can't duplicate a comparable learning experience in your own home.

An educational retreat can be a fun enterprise for you and your quilting bee to stage, but if you need some time alone, just you and your stash, it's also a great justification to close the door and get crafty.

Day One

- Arrival and Introductions

- Identifying the Three Ingredients of Color from your Scraps (pages 21, 31, and 38)

- Create your Color Journal (page 11)

- Create a Color Wheel from your Stash (page 22)

- Identifying the Six Color Wheel Recipes (use chart on page 29)

Noon – Break for Lunch

- Make a Value Wheel from your Stash (page 33)

- Make an Intensity Wheel from your Stash (page 39)

- Discerning the Color Elements in your Fabric Collections (page 40)

- Selecting and Testing your Provence Quilt Color Swatches (page 55)

- Show and Tell at Day's End

Day Two

- Fine-Tuning the Provence Quilt Color Harmony

- Make Provence Quilt (use instructions on page 56)

- Show and Tell at Day's End

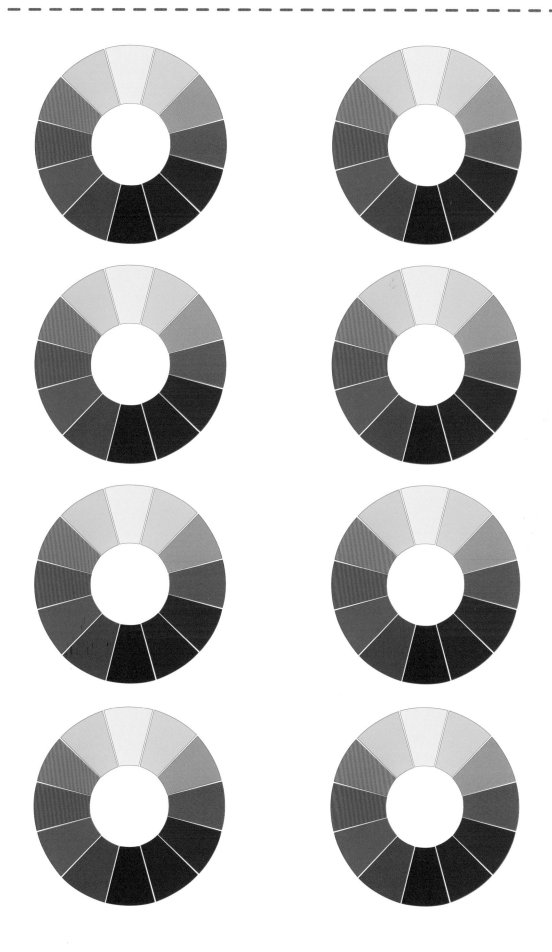

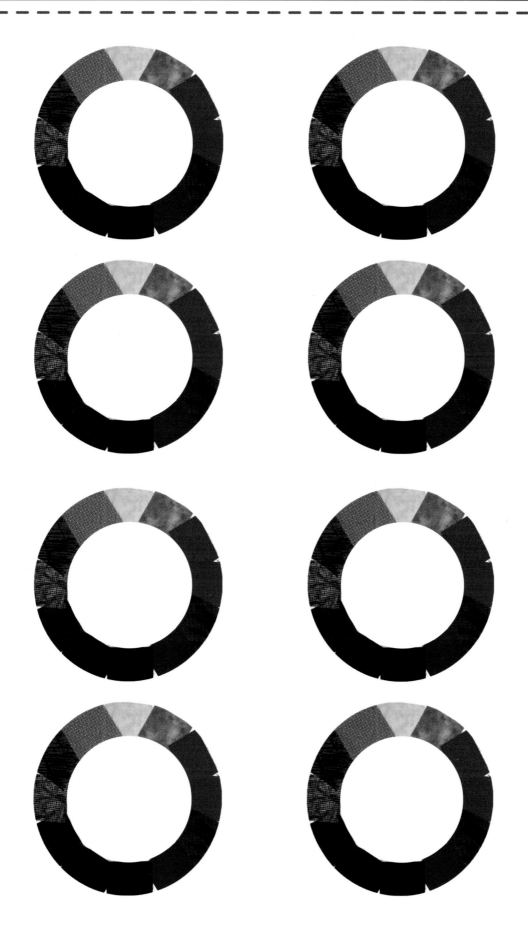

Color Harmony	Description	Sample Fabric Swatches
	Analogous harmony is achieved by using two to five colors close to each other on the color wheel. The result is a low-contrast harmony that blends well.	
	Complementary harmony is achieved by using two colors opposite each other on the color wheel. The result is a high-contrast harmony that provides great definition for design elements such as quilt piecing, appliqué, and separating foreground and background.	
	Round-Robin harmony is an Analogous harmony that contains lesser amounts of each successive color. The result is a low-contrast color harmony.	
	Triadic harmony is achieved by using three colors spaced evenly apart around the color wheel (four spaces apart). The result is a medium-contrast harmony that's successful every time, no matter which three colors you use.	
	Split-Complement harmony is achieved by using one color, plus the two colors on either side of its complement. The result is a medium-contrast harmony that always works well, regardless of the starting color.	
	Double-Complement harmony is achieved by using two pairs of opposite colors on the color wheel. The result is a higher-contrast color harmony that has more colors than a normal Complementary harmony and generates less focus on each color.	

Color Harmony	Description	Amount of Contrast
	Round-Robin harmony is an Analogous harmony containing lesser amounts of each successive color. With little contrast, the colors blend together.	Lowest
	Analogous harmony is the result of using two to five colors close to each other on the color wheel. It yields a low-contrast harmony that blends well.	Low
	Triadic harmony is the result of using three colors spaced evenly apart around the color wheel (four spaces apart). Its balance of medium contrast and color variety could be the perfect combination.	Medium
	Split-Complement harmony is the result of using one color, plus the two colors on either side of its complement. Its medium contrast is balanced by two colors that blend well together.	Medium
	Double-Complement harmony results from using two pairs of opposite colors on the color wheel. It yields high contrast from colors that do not blend.	High
	Complementary harmony results from using two colors opposite each other on the color wheel. This yields the highest contrast from colors that do not blend.	Highest

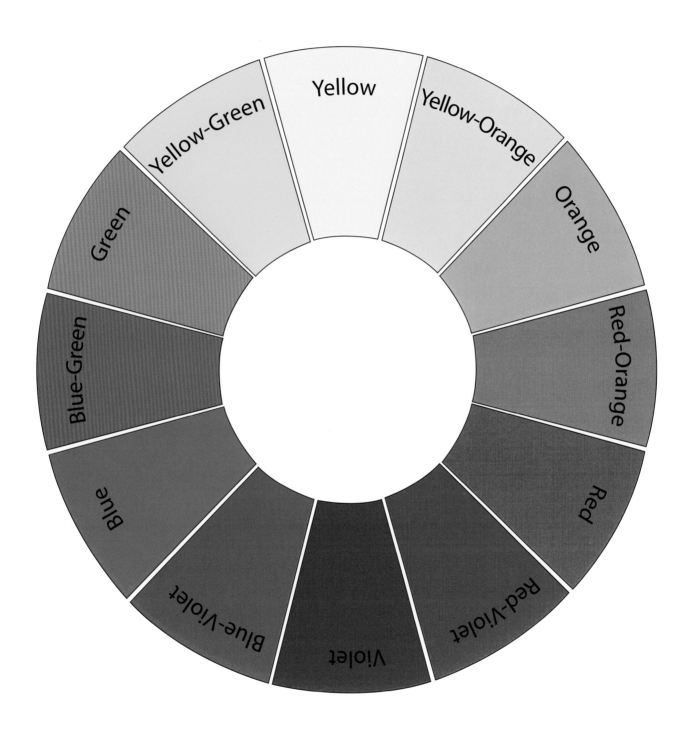

BIBLIOGRAPHY

Albert, Greg. *The Simple Secret to Better Painting*. Cincinnati: North Light Books, 2003.

Boynton, Lee, and Linda Gottlieb. *Painting the Impressionist Watercolor*. New York: Watson-Guptill, 2004.

Edwards, Betty. *Color by Betty Edwards: A Course in Mastering the Art of Mixing Colors*. New York: Jeremy P. Tarcher/Penguin Books, 2004.

Marston, Gwen, and Joe Cunningham. *Quilting with Style: Principles for Great Pattern Design*. Paducah: American Quilter's Society, 1993.

Marston, Gwen. *Lively Little Folk-Art Quilts*. Lafayette, CA: C&T Publishing, 2006.

Mashuta, Mary. *Confetti Quilts: A No-Fuss Approach to Color, Fabric and Design*. Lafayette, CA: C&T Publishing, 2003.

Perry, Gai. *Color from the Heart: Seven Great Ways to Make Quilts with Colors You Love*. Lafayette, CA: C&T Publishing, 1999.

Stanley, Andy. *Visioneering*. Colorado Springs: Multnomah Publishers, 1999.

Tharp, Twyla. *The Creative Habit: Learn It and Use It for Life*. New York: Simon & Schuster, 2005.

Maria Peagler enjoys making an eclectic range of quilts, from fine art to funky traditional. She has won fine art awards for her quilts and is the award-winning author of eight books. Maria earned a Journalism degree from the University of Georgia, one of the top five Journalism colleges in the United States. Before staying at home with her children, Maria was Director of Courseware Development for the nation's largest computer training company.

Maria specializes in awakening the creative spark in quilters who doubt their own ability. Maria lives in the Appalachian mountains with her husband and two sons. In her little spare time, she enjoys watercolor painting and daily hikes in the mountains.

Visit Maria's website and blogs to extend the lessons in this book and to learn more about Maria and her classes:

http://www.colormastery.com
http://www.mariapeagler.com
http://quiltsandcreativity.com

NOTES

NOTES